THE NIKON HANDBOOK SERIES:

Color Photography

Joseph D. Cooper and
Joseph C. Abbott

AMPHOTO
American Photographic Book Publishing Co., Inc.
Garden City, New York

Copyright © 1979 by American Photographic Book
Publishing Co., Inc. Published in Garden City, New
York by American Photographic Book Publishing
Co., Inc. All rights reserved. No part of this book may
be reproduced in any form whatsoever without written
permission of the publisher.

Library of Congress Cataloging in Publication Data

Cooper, Joseph David, 1917-1975.
 Color photography.

 (The Nikon handbook series)
 Includes index.
 1. Color photography. I. Abbott, Joseph C., joint
author. II. Title. III. Series.
TR510.C58 1979 778.6 79-13222

ISBN 0-8174-2493-8 (hardbound)
ISBN 0-8174-2165-3 pbk. (softbound)

Manufactured in the United States of America

Contents

NOTE FROM THE PUBLISHER

The Nikon Handbook Series was previously published as *The Nikon Nikkormat Handbook*. The series was compiled from *The Nikon Nikkormat Handbook* and the supplements that were used to update it. As the series goes to press, it contains the latest available information on Nikon equipment.

Except for the cover photograph, the photographs in this book were previously published in *The Nikon-Nikkormat Handbook* and in the supplements that were used to update it. Cover photo by Michael Melford.

ACKNOWLEDGEMENT

Grateful acknowledgement is hereby made to Mark Iocolano for his assistance in preparing this work for publication.

PHOTOGRAPHERS PRESENTED IN THIS SERIES

All photographers are from the United States unless specified otherwise.

Joseph C. Abbott
Susanne Anderson
Weston Andrews
Edwin L. Appleton, United Kingdom
Jim Arnett
H. J. P. Arnold, United Kingdom
Backus and Andriessen, Holland
Jean-Francois Bauret, France
R. K. Bickerton
Ken Biggs
T. P. Bligh
Ian Bradshaw, United Kingdom
Norman Brand, United Kingdom
Bill Campbell
Tom Carroll
Ron Church
John Brett Cohen, South Africa
Dean Conger
Byron S. Cooper
Joseph D. Cooper
Cousteau's group, France
Gerry Cranham, United Kingdom
Ralph Davis
Joe DiMaggio
Bob DiNatale
Joseph Dombroski
David Doubilet
Graham Finlayson, United Kingdom
Roland L. Freeman
Mark Garanger, France
Jean Gauthier, Canada
Al Giddings
M. Goetz, South Africa
Bill Goldstein
Alfred Gregory, United Kingdom
George Harvan
Francisco Hidalgo, France
Suzanne G. Hill
Frank Herholdt, South Africa
Edwin Hirsch
N. R. Hoferichter, Canada
Mark Iocolano
Don Jacobsen
Peter Keen, United Kingdom
Richard Kraus
Gerald Lacey, United Kingdom

J. D. Levine
Robert T. Little
Douglas Lyttle
Mayotte Magnus, United Kingdom
Dan McCoy
Jack McKenney
Stan Menscher
Douglas T. Mesney
Peter Millan
Peter Miller
John Minihan, United Kingdom
Bob Nemser and Bill Jorden
Robert Pastner
Robert Provin
Carl Purcell
Raghu Rai, India
Anne B. Reinstein
Bill Risdon, United Kingdom
Struan Robertson, South Africa
Chuck Rogers
Dave Rummell
Fred Santomassino
Al Satterwhite
Flip Schulke
Ted Schwarz
Tomas Sennett
Mark Seymour, United Kingdom
Stephen M. Shapiro
Jeanloup Sieff, France
Vernon Sigl
Bernd Silver
John D. Slack
Chris Smith, United Kingdom
Ken Spencer
William C. Straka
Patrick Thurston, United Kingdom
Richard Tucker, United Kingdom
Tim Turnbull
Peter Turner
Ian Vaughan, United Kingdom
Julius Weber
Larry West
Stanley Wolfson
Richard Yarwood
Robert Young, United Kingdom
Chris Yuin

The Nature of Color

Presumably, one could make excellent color photographs without any knowledge whatsoever of either the physical properties of light or the technical nature of color films. The viewer's appreciation of a photograph does not rest on the use of filters, color temperature meters, primary and secondary colors, or any of the technical considerations that went into its making. Rather, a photograph is judged according to a variety of subjective factors which cannot be quantified. Just as a painter must understand how to mix and use the colors of his palette, however, the photographer should understand the nature of his materials—light and film.

PROPERTIES OF LIGHT

The Visible Spectrum

Radio waves, X-rays, microwaves, infrared radiation, ultraviolet, gamma rays, and light are all part of a continuous spectrum that is called *electromagnetic radiation*. This radiation travels in "waves;" the specific types of radiation are characterized by the length of these waves. Radio waves can be miles long; gamma waves have the shortest wavelengths, less than one ten-billionth of an inch. Occupying a narrow intermediate band is radiation to which our eyes are sensitive, and this is visible light.

The wavelengths of visible light are measured in billionths of a meter. This range is further broken down into ranges which relate to different colors. Red, for example, has the longest wavelength and blue (or violet) the shortest. White light consists of red, blue, and all the colors in between, which make up the colors of the familiar spectrum.

Additive Color—The Primaries

White light can be made by combining light of just three colors—red, blue, and green. In fact, any colors can be made by combining any two of these colors in various proportions. Red, blue, and green are the primary colors of light, and, because any color can be made by adding these in varying amounts, they are also called the additive colors, or the additive primaries. (The primary colors of light should not be confused with the primary colors of paint or pigment, which are red, blue, and yellow.)

An excellent example of the additive nature of these three colors is the photograph by Richard Tucker on plate XVI-C-6. Three exposures were made successively through red, blue, and green filters, which only admitted light of their respective colors. The natural appearance of the sky in this photograph results from the fact that the different filters admitted all the red, blue, and green light present, thus creating the equivalent of a single white-light (unfiltered) exposure.

Next, examine the highlights, or sparkles, on the water. In a conventionally

exposed photograph, these would, of course, be recorded as white patches. Because they were constantly moving, the sparkles are seen in different positions for each of the three exposures. Consequently, they appear as green, red, or blue patches, depending upon their positions during each exposure. Intermediate colors, caused by the mixing of two of the primaries, may be observed where two highlights overlapped for two of the three exposures.

The explanation of the colored figures in the Tucker photograph, occurring because the people did not stay in place for all three exposures, is left for the following section, which describes the secondary colors.

Francisco Hidalgo's photograph at the top of plate XVI-C-5 is another example of the tricolor multiple-exposure technique. To make this picture, Hidalgo zoomed the lens between exposures.

Subtractive Color—The Secondaries

As has been stated previously, all colors can be made by mixing two of the primary colors in various proportions. When two primaries are mixed in equal amounts, the result is a secondary color. The secondary colors (for light, not pigment) are cyan (blue + green), magenta (red + blue), and yellow (red + green).

How the colored figures in Richard Tucker's photograph were made should now be easier to understand. It is important to realize that these figures are silhouettes, reflecting no light and color of their own; rather blocking light from the background, which is in this case, the sky. Consider first the yellow figures. The two people whose outlines are represented stood in position only during the exposure made through the blue filter. Light from the sky struck that part of the film only during the exposures made with the red and green filters, and the outline which resulted is the secondary color made from red and green, which is yellow. (Although the sky appears blue, it contains traces of all three primary colors.) Similarly, the people represented by the two cyan figures stood in their positions only during the exposure made through the red filter. The color omitted from the silhouettes in this case is the red component of the sky, and the green and blue light which was permitted to strike the film in the other two exposures combined to create cyan. The middle figure, that of the diver, was in position during the exposure made with the green filter, thus the figure was rendered magenta, the combination of red and blue. Because the blue sky had a scarcity of red light, the magenta color of the diver has a purple-blue cast.

If Tucker had wanted the figures rendered as one of the primary colors, he would have instructed the models to remain in position for two of the three exposures (clearly, a difficult task for the diver). Thus, the figures would have permitted only one of the primary colors to strike the film.

For practical reasons, the secondary colors have more importance to the photographer than the primaries. This is because a filter made of a primary color will transmit, or allow to pass through, only light of its own color; all other colors are blocked. A filter made of a secondary color transmits all light except that of the color excluded from its makeup. Magenta (red + blue), subtracts green, cyan (blue + green) subtracts red, and yellow (red + green) subtracts blue.

The secondary colors are often referred to as the subtractive colors because they remove only one component of all the existing light.

With this in mind, it is easy to see why photographers tend to use filters of secondary colors to create intermediate colors. When filters of secondary colors are combined, each will subtract certain amounts of a specific color; all other colors will pass through the filter combination. To create red, for example, you can combine equal amounts of yellow and magenta. Yellow subtracts blue and magenta subtracts green. Thus, red remains. Of course, it's rather pointless to create red in this manner because red filters are available. To make orange, however, use a yellow filter that is denser than the magenta filter. Because primary-colored filters transmit only light of their own color, these filters can't be combined to create other colors; no light at all will pass through the combination. A similar effect occurs when filters of all three secondary colors are combined. Each filter subtracts one of the primaries, introducing a component of grey, or "neutral density."

Remember these rules of color formation: When red light, blue light, and green light are mixed, white light results. Light of two of these colors, in equal amounts, creates a secondary color. To use filters to create other colors, rely on the subtractive (secondary) colors, because primary-colored filters can't be combined. Yellow subtracts blue, magenta subtracts green, and cyan subtracts red.

PROPERTIES OF FILM

How Color Film Works

The various color films available differ widely in many respects, but they are basically alike in that they consist of three separate light-sensitive emulsion layers. The top layer is sensitive to blue light, the middle layer is sensitive to green light, and the third layer is sensitive to red light. Blue subjects affect the blue-sensitive layer, green subjects affect the green-sensitive layer, and red subjects affect the red-sensitive layer. A secondary color affects two layers. Magenta, for example, affects both the red-sensitive and blue-sensitive layers. Cyan affects the green-sensitive and blue-sensitive layers and yellow affects the red-sensitive and green-sensitive layers. White light affects all three layers. Any color, then, will affect one or two layers of the film.

During development, dyes are put into the light-sensitive layers. The exact methods of doing so vary greatly from film to film, but essentially there are two sequences: color negative and color transparency.

In the negative process, the film is developed so that metallic silver forms in the areas affected by light. At this point, the film consists essentially of three black-and-white negatives corresponding to the relative intensities of red, blue, and green in the subject. In the next step, color dyes are formed in all the places where silver is present. The dye is the "opposite" color; yellow dye forms in the blue-sensitive layer, magenta dye forms in the green-sensitive layer, and cyan dye forms in the red-sensitive layer. The final step before fixing and washing the film

is to bleach out all the metallic silver in the film, leaving behind the colored dyes. The reason that dyes of the secondary colors are used has previously been mentioned; light can pass through all three layers, subtracting only selected colors.

In the negative, areas struck by blue light appear yellow, green subjects appear magenta, and red subjects appear cyan. Areas stuck by light of a secondary color will have dyes in two adjacent layers. A magenta subject, for example, affects the red-sensitive and blue-sensitive layers. These layers are dyed cyan and yellow, respectively. This area of the negative will therefore appear green (cyan + yellow). Similarly, a cyan subject appears red (magenta + yellow dye layers), and a yellow subject appears blue (magenta + cyan dye layers). An overall orange cast is visible in the negative; this is a built-in mask designed to compensate for color deficiencies inherent in the dyes.

An additional step is necessary when transparencies are made. First, as before, the film is developed to create three black-and-white negative layers. Unexposed emulsion remains in the areas not originally affected by light. This previously unused emulsion corresponds to a positive image of the subject, and it is from this part of the film that the final image is made.

After the first development is completed, the film is fogged, either by chemical action or by reexposure to light. Then, redevelopment brings out the positive image in the fogged, previously unaffected areas. This process is called "reversal." The color dyes are placed in this positive image. The dyes are the same as those in the negative process, with different positions. Compare the following examples with those discussed in the description of the negative process.

A blue subject affects only the blue-sensitive layer of the film; the green-sensitive and red-sensitive layers remain unexposed. In reversal processing, the green-sensitive and red-sensitive layers are fogged and redeveloped. Then, magenta dye is put in the green-sensitive layer and cyan dye is put in the red-sensitive layer. The blue-sensitive layer, of course, is bleached clear. Magenta and cyan together form blue, the color of the original subject. Red and green are formed the same way; two adjacent layers which were originally unexposed receive dyes which together create the original color.

Remember that secondary colors originally affect two emulsion layers. That leaves only one unexposed emulsion layer, which will receive the dye of the original secondary color in the final transparency. The two layers originally affected will be bleached clear. Yellow, for example, affects the red-sensitive and the green-sensitive layers. In processing, yellow dye is placed in the originally unaffected blue-sensitive layer. The other two layers become transparent. Magenta and cyan are reproduced in similar ways.

Transparency or Negative?

The first choice that a photographer usually makes in selecting a particular color film is between color negative or color transparency (reversal) film. These two broad categories have, in general, important differences in terms of exposure latitude, the need to use filters in special situations, the methods in which prints and transparencies are made from each, and the stability of the color image.

In all cases, films will provide the best quality images when they receive the correct exposure. In practice, however, slight deviations from correct exposure will produce acceptable, although not optimal, results. The degree to which films possess a margin for error is termed "exposure latitude." Exposure latitude also relates to the maximum subject brightness range which the film can handle without blocking up the shadows or washing out the highlights.

Color negative films tend to have greater exposure latitude than reversal films, although neither approaches the latitude of the general-purpose black-and-white films. Color negative films have more latitude in the area of over-exposure than under-exposure; reversal films have little in either direction, but slight under-exposure is usually less disastrous than overexposure.

The final product of negative films is a reflection print made from the negative. As in black-and-white work, corrective measures may be taken when the print is made. With both color and black-and-white photographs, the printer may selectively lighten or darken certain areas of the print. In color work, the overall color balance of the print can also be altered through the use of color printing filters. The final product of transparency film is the color slide, which is the original piece of film exposed in the camera. While corrections are possible through transparency duplicating or print-making processes, they tend to be more difficult to execute.

Color negative films are primarily intended to produce color prints and reversal films are intended to produce transparencies, although it is possible to make prints from slides and transparencies from color negatives. Until recently, color prints made from transparencies were usually inferior in quality to those made from negatives, but recent technical advances have all but eliminated this discrepancy.

Prints from slides are made in one of two ways—the internegative, "Type C," method and the reversal method. The Type C method requires making a color internegative from the transparency. The internegative, made on a special negative film, is then printed conventionally. The reversal process uses special reversal printing paper, such as Kodak Ektachrome RC, Type 1993. In this process, the print is made directly from the slide. Another method, Cibachrome, is similar in that it is also a reversal process, but it differs chemically from the other reversal process and produces a much different appearance in the final print.

The results of all three processes differ in color saturation, contrast, and reproduction of various colors as compared to the original slide. The choice of which process to use in analogous to the selection of a particular film.

Transparencies can be made from color negatives by printing on a print film, which is essentially a color printing paper with a transparent backing.

For the purposes of publication, it is easier for the engraver to reproduce transparencies than color prints. When the latter are submitted, transparencies are usually made from them. For this reason, most professional work is done on reversal film, except in those cases in which a display print is intended to be the final product.

No color process is as permanent as a properly processed and washed black-and-white print. All color dyes fade over time, and that change is accelerated with exposure of the prints or transparencies to sunlight. Color photographs will retain

their color longer if they are stored in a cool, dry, and dark place. Of the various films available, color negatives are most vulnerable to the effects of time. Color slides, particularly Kodachrome, fade less slowly.

Selecting a Film

Once the choice between negative and reversal processes is made, a wide selection of films remains from which to choose. The selection of a particular film depends upon film speed, grain, overall color rendition, and other factors.

Among the negative films available, most have ASA ratings of 100 or 400. The ASA 400 films permit photography when great depth-of-field is needed, when the light is dim, when fast shutter speeds are needed, or when lenses having narrow maximum apertures are used.

For general use, when there is no particular need to use the ASA 400 film, the slower films are the better choice. They have slightly greater sharpness and less grain than their faster counterparts.

Reversal films offer a greater selection than negative films. The film speeds range from ASA 25 to ASA 400. The reversal films can, therefore, be classified into four categories based on film speed. These are slow speed, medium speed, high speed, and ultra-high speed.

Films in the slow-speed category have ASA ratings between 25 and 50. The most widely used film in this category is Kodachrome 25. Other films are Ektachrome 50 Professional (Type B) and Kodachrome 40 Professional (Type A). These films have outstanding sharpness and very fine grain. They are excellent for situations in which plenty of light is available. Many photographers use Kodachrome 25 as a general-purpose film, despite its slowness, because of its outstanding sharpness and color fidelity.

The medium-speed category includes films with speeds between ASA 64 and ASA 100. Kodachrome 64, Ektachrome 64, Agfachrome 64, Agfachrome 100, and Fujichrome 100 are in this group. These films have very fine grain and sharpness and are excellent for general-purpose use.

The high-speed group includes such films as Ektachrome 200 and Ektachrome 160 (Type B). These films are best suited for use in low light conditions, when fast shutter speeds are needed. Often they are push-processed one or two f/stops to achieve even higher effective exposure indexes. High-speed films tend to be grainy, but their grain and sharpness characteristics have improved considerably in recent years. With the increasing use of color photography in newsmagazines, photojournalists have come to rely heavily upon these films.

The ultra-high speed category includes films faster than ASA 200, such as Ektachrome 400. This slide film can be push-processed to exposure indexes up to 1600 with acceptable results.

When the film speed criterion are applied to the selection of a film, it is important to remember that, in general, the best sharpness and image quality is obtained when the slowest film practical for a specific situation is selected. The level of illumination you are likely to encounter isn't the only factor to consider. The speed of the film in use affects the choice of shutter speed and lens aperture

settings which can be used for a specific lighting situation. If a high-speed film is used on a fairly bright day, you will be forced to use small apertures or fast shutter speeds, or possibly both. The resulting depth-of-field or motion-stopping qualities may be undesirable for the particular photographs. If, for example, you wish to make candid photographs of passers-by on a crowded street, you probably will want a fairly shallow depth-of-field. Fast films on bright days usually require small apertures. The great depth-of-field can ruin an otherwise excellent photograph. One way out of such a situation is through the use of neutral-density filters, which block out light of all wavelengths equally, effectively "reducing" the speed of the film.

Alternately, you may want to use a fast film on a bright day for situations such as sporting events usually, which require the use of fast shutter speeds and telephoto lenses having small maximum apertures.

Each of the color reversal films available renders color in a unique manner. Kodachrome, for example, is widely known as a "warm" film: It emphasizes reds and yellows. Ektachrome is a "cool" film: It emphasizes blues and greens. Agfachrome's manufacturers refer to their products's "European color," which they define as softer, subtler, and more subdued than that of other films. The photographs on plate VIII-C-6 demonstrate the differences in color rendition between Fujichrome and Ektachrome.

Fortunately for manufacturers of films, and probably for photographers as well, people have a poor ability to remember color precisely as it appears. If shown them separately, a person who saw the subjects depicted in the photographs on plate VIII-C-6 at the time they were photographed would probably say that each of the photographs has a good likeness of the subject. In fact, it is unlikely that any of the pictures represent exact duplicates of the colors acually present in the original subject.

The Color Balance of Films

Unless a light source is strongly monochromatic. it is usually perceived as "white." Sunlight, light from a table lamp, a street lamp, and a fluorescent lamp generally appears white because it contains most of the colors of the visible spectrum. All these sources, however, possess different proportions of the various wavelengths. Certain colors, in fact, are entirely absent from fluorescent light, which appears green on film.

"Color temperature" refers to the color content of a light source. Technically speaking, color temperature refers to the temperature, expressed in degrees Kelvin, of a theoretical body which emits light of a characteristic spectrum when heated to various levels. The Kelvin scale is equivalent to the Centigrade scale, except that it begins at absolute zero, which is minus 273°C. As the object is heated, all the energy applied to it is radiated outward—much of it as visible light. The higher the color temperature, the greater the proportion of blue light in the spectrum. Some practical examples may simplify this explanation.

A 100-watt household light bulb emits a spectrum equivalent to that of a theoretical body heated to approximately 2800° Kelvin (2800°K, or simply, 2800K).

Thus, we say that the color temperature of a 100-watt household light bulb is 2800K. It is deficient in blue light, compared to other sources. A tungsten photolamp burns at 3200K and certain other artificial sources burn at 3400K. Daylight is considered to have a color temperature of about 5500K, although this figure varies depending on time of day and weather conditions.

Our perception adjusts for all of these differences, so, with movement from one lighting situation to another, all of these sources are perceived as white. Only when two different sources are perceived simultaneously can the difference be easily discerned. To test this phenomenon, examine a piece of white paper by diffuse window light at noontime. Then, turn on a lamp near the window so that its light also falls on the paper. The relatively orange cast of the lamp light is easily seen.

Color films are unable to make the adjustment between light sources of different temperatures, and are therefore "balanced" for a particular source. The relative sensitivities of the three emulsion layers are adjusted in order to provide a natural-appearing color rendition when the film is exposed to light of a specific color temperature. Films are balanced for one of three different color temperatures: 3200K (Type B), 3400K (Type A), and Daylight (5500K.) Of the two types intended for tungsten lighting, Type B films are more widely used. Type A films are used with studio photofloods or motion picture lighting instruments. Daylight films are used with both daylight and electronic flash.

If films are exposed to light other than that for which they are balanced, the color rendition will be unnatural. If the light has too low a color temperature for the particular film, the overall cast will be reddish-orange. If the color temperature of the light is greater than that for which the film is balanced the overall effect will be bluish.

Using the proper film for the light source is crucial with reversal films; it is less important with negative film. Most color negative films should be exposed by daylight or electronic flash. In practice, adjusting the color printing filter pack will correct many of the unnatural color casts created by exposing negative film to light of the improper color temperature. It is better, however to use filters at the time of the original exposure, as described below.

When films must be exposed by light sources other than those for which they are balanced, filters should be used over the lens. An alternative which is sometimes practical is to use filters over the light source. The filters subtract some of the wavelengths that are in excess for a particular film/light source combination. For example, tungsten films (Types A and B) have an increased sensitivity to blue, which compensates for tungsten light's inherent deficiency of that color. If these films are exposed by daylight or electronic flash, the transparency will have an overall blue cast. The filter to use is one of the deep-amber 85-series. If a daylight film is used with tungsten light, a deep blue filter of the 80-series is required.

Filters which alter the color rendition of film fall into three categories: color conversion, light balancing, and color compensating. The color conversion filters are the filters described in the preceding paragraph. They are used to allow films balanced for one type of light to be exposed in another type of light.

Filters in the 81-series and the 82-series are light balancing filters. The 81-series

consists of filters in various grades of pale amber; the 82-series filters are pale blue. These are "warming" and "cooling" filters, most widely used to compensate for the various colors of sunlight at different times of day or under various weather conditions. They may be used in any situation in which the lighting conditions produce an effect too warm or too cool for the photographer's liking.

The third category consists of the color compensating filters. Unlike the ones in the previous categories, these filters generally come as thin gelatine sheets for use in a filter holder, rather than as glass screw-in types.

The color compensating filters come in six colors; the three primaries and the three secondaries. All six colors come in a wide range of densities, from 0.025 to 0.50 (Each 0.10 increment equals about 1/3 f/stop transmission loss.) These filters are used singly or in combination to make changes in the overall color balance and to compensate for deficiencies in the quality of the existing light. For example, many photographers use a magenta filter when they expose daylight-balanced films under fluorescent lighting, which otherwise tends to appear green to the film. Color compensating filters are also extensively used in underwater photography to counteract the tendency of water to absorb the red-orange wavelengths at progressively greater depths.

Professional and Amateur Films

Some films are designated as "professional" emulsions. They are not, of course, available only to professional photographers, nor do professionals use them exclusively. The professional films are not much different from those intended for amateur use except that they are marketed and handled so as to give the photographer greater assurance about their consistency.

As film ages, the color rendition tends to drift from being slightly in excess of one color, through an optimal "aim point," then toward an excess of a complementary color. This aging process may be retarded or halted by refrigeration or freezing.

A manufacturer will ship a batch of film designated for amateur use from the factory before it reaches the "aim point," calculating that after the film is shipped, held in the dealer's inventory, and ultimately used, it will approach the optimal color balance. If not, the deviation will be so slight as to be unnoticeable and unobjectionable to the user.

In many professional situations, exact color balance is critical, particularly when a product which has a characteristic, identifiable color is depicted, or when the photographer is critically concerned with getting as faithful and consistent a rendition of flesh tones as possible. Professional films, therefore, are shipped from the factory at the "aim point" and are kept under refrigeration at all times. (Buying a professional film from a dealer who doesn't refrigerate his inventory is an exercise in futility.) The professional photographer keeps his film in the refrigerator until a few hours before use and has the film processed immediately after shooting.

Some of the Kodak professional films are tested, batch by batch, to determine the exact ASA rating. The manufacturing tolerances of color-film emulsions per-

mit a deviation of about 1/3 f/stop from the indicated film speed. In non-critical applications, this deviation is unobjectionable. In many critical professional situations, however, it can be disastrous. Kodak prints the actual speeds of the tested batch on the instruction sheet packed with the particular roll of film.

The consistency of the amateur films is generally very good, and many professionals even use them to a great extent. Many professionals rely on Kodachrome 25 or Kodachrome 64, although these are not classified as professional films. If their requirements are particularly critical, professionals will often buy many rolls of these films, all with the same batch number, and test a few rolls. If the characteristics of that particular batch are acceptable, the remainder of the film is refrigerated.

EXPOSURE CONTROL

Exposing Color Films

Proper exposure is essential in all photography, but it is especially so in color photography. The reason is two-fold: color films have less exposure latitude than black-and-white films, and the consequences of improper exposure are more difficult to correct in color. An understanding of exposure-metering techniques is essential for the photographer working in color.

Most metering is probably done with reflected-light meters; all through-the-lens metering systems work this way. The reflected-light meter measures from the camera's point-of-view light reflected from the subject. The meter is designed to recommend an exposure which will render the subject medium-density tone. For black-and-white work, the photographer should be careful to measure a middle-gray part of the subject or to measure some other tone and compensate accordingly. Black-and-white exposure technique relates the brightnesses of the subject to steps on a gray scale. Color exposure technique works differently.

The photographer working in color should instead consider exposure technique as a determination of color saturation. When too little exposure is given, color is barely discernable; everything looks muddy and lacks detail. As exposure is increased, colors begin to emerge from the murk, and detail becomes visible. Highlights, however, lack brilliance. As exposure is further increased, shadow detail becomes more pronounced and colors increase in saturation.

A properly exposed photograph has good shadow detail, well-saturated hues, and "clean" highlights. As exposure is further increased beyond this point, colors begin to bleach out and highlight areas turn blank white. With a high degree of overexposure, detail is lost in everything but the shadows, and the photograph looks washed-out and unnatural. Arriving at the correct exposure, then, is a balancing act between a murky result and a bleached-out one. The dividing line is often extremly fine.

The photographer working in available light with a through-the-lens metering system should carefully exclude from the meter's measuring area bright patches or dark areas which don't relate to the main subject matter. These areas can fool the meter, which integrates all the subject brightnesses, into giving a reading that is unsuitable for the main area of interest. With reflected light meters, such as

through-the-lens systems, the rule of thumb is to point the meter at the area in which you want to show good detail and natural-appearing color saturation. Unless that particular area is illuminated wildly unevenly, this approach will usually yield acceptable results.

A hand-held meter of the reflection variety is used the same way as a through-the-lens meter, but the hand-held meter offers several advantages. The hand-held meter is generally usable in a wider range of light intensities than the camera's built-in meter. In addition, the hand-held meter is easier to use for selective measuring of small areas within the subject field. The subject brightness range is thus determined, giving the photographer an indication of which areas of the finished photograph will show detail when a particular exposure is used.

The other type of meter, which is always the hand-held variety, is the incident light meter. Meters of this type have a large hemispheric diffusing dome. Incident-light meters measure the intensity of light falling on the subject, and therefore are used either at the subject position or at a position which is illuminated exactly the same as the subject. The incident meter should indicate the same exposure as a reflection meter which is pointed at a middle-gray tone.

Incident meters are used widely in motion picture photography because the cinematographer is concerned with adjusting the levels of illumination so that the subject will have the same tonality in every shot. When the lighting level is constant, for example, on the actor's face, and the camera controls are not changed, the skin tone reproduction will be consistent from shot to shot.

It is important to remember that the incident meter conveys absolutely no information about the subject's reflectance level. If the subject is highly reflective, the setting indicated by the meter could result in overexposure. If the subject is dark, the incident meter probably will indicate underexposure. Always consider the brightness of the subject matter and compensate accordingly to bring the subject into the narrow range of acceptable exposure. The incident light meter can be as useful for color work as the reflected light meter.

A few other types of meters deserve brief mention. The flash meter, which can be the reflective or incident type, is designed to respond quickly and accurately to the very brief bursts of light associated with flash photography. The flash meter is useful because it eliminates the guesswork which is often necessary even when the "guide number" of the flash unit is known. The different models available vary greatly in price and degree of sophistication.

The other type of meter relevant to color photography is the color temperature meter. It measures the relative intensities of the various wavelengths contained in existing light so that the photographer can use filters to exactly balance the particular film to the lighting conditions. The simplest type of color temperature meter measures the relative proportions of red and blue. It enables the photographer to compensate for the changing quality of daylight or incandescent light indoors. The more sophisticated type of color temperature meter takes two measurements; the relative proportions of blue and red, and the relative proportions of green and red. The photographer may then use filtration to effectively fine tune the relative sensitivities of all three emulsion layers of the film. The tricolor meter, as this type of meter is called, is essential when the green component of existing light is significant. Photographers who must work under illumination

from fluorescent lights, mercury vapor lights, or mixed lighting find the tricolor meter indispensable.

Exposure Latitude

As previously demonstrated, color films in general have far less exposure latitude than black-and-white films. The photographer should take these characteristics into consideration when working with various films.

Color negative films have the most exposure latitude of all color films. In general, if the subject has brightness range of about 8:1 (three f/stops), all of the parts of the subject should reproduce well when the film is exposed for the middle of this brightness range.

If the brightness range of the subject is narrower than 8:1, even an incorrect exposure may produce reasonably acceptable results provided the deviation from correct exposure is not too great. The correction procedure is similar to that used for black-and-white: The print exposure is lengthened or shortened to adjust for the negative density.

If the brightness range of the subject is greater than approximately 8:1, the film will not record detail in all parts of the picture. You must then expose carefully to insure that the most important areas of the subject in which you want to show detail will fall within the film's narrow range of acceptable exposure.

If, for some reason, deviation from the ideal exposure is unavoidable, it is best to overexpose when working with color negative film. Consider, for example, a situation in which you have a subject with a brightness range of 16:1 (four f/stops). If you underexpose, the three brightest parts of the scene will fall within the acceptable range of the film; the darkest important area will show no detail. If you overexpose, the brightest part of the scene will record as an excessively dense area of the negative; the three areas of lesser brightness will all show detail. When the print is made, the overexposed area can be "burned-in." Of course, this approach will not reproduce that area with the same degree of quality as if it were properly exposed. However, the compromise of overexposure will capture at least some detail in all four of the important areas of the photograph. When any important area is underexposed, no corrective procedure can add detail where it was not originally recorded on the film.

Reversal films have less latitude than negative films, and because the in-camera exposure is also the final photograph, proper exposure is even more critical. The acceptable brightness range for transparency films is about two f/stops (4:1). This means that any part of the scene that is more than twice, or less than half, as reflective as the most important part of the subject will not be recorded in any detail. As in the previous example, consider a scene with a brightness range of 8:1 (three f/stops), which is greater than that which the film is capable of recording. Assume that all three areas are of equal importance, however, the film can record detail in only two of them. The choice the photographer must make is between overexposing the brightest area or underexposing the darkest area. Underexposure is generally the better choice, because people are accustomed to being unable to see into shadows, even if they suspect that the shadow obscures

important parts of the subject. If parts of the subject appear bleached and washed-out, as would be the case with overexposure, the photograph looks unnatural and objectionable.

When the lighting is fairly flat, slight underexposure can sometimes improve a photograph made on transparency film. Peter Keen's photograph at the bottom of plate VIII-C-1 illustrates this technique. Notice that the parts of the child's body which are in shadow show no detail. If Keen had given about 1/2 f/stop more exposure, he would have been able to record a little more shadow detail without obliterating the brighter parts of the scene. The subtle textures and colors of the wall and door, however, would have lost their effectiveness, and the overall mood of the photograph would change greatly.

Mark Garanger's photograph of the children in the courtyard on plate XVII-C-5 also illustrates the importance of precise exposure. Exposing for greater detail in the shadow areas would have diluted the colors of the wall and the clothing, and the visual impact created by the contrasting hues would have been lost.

Bracketing

While it is sometimes condemned as a safety cushion for photographers who don't know what they're doing, exposure bracketing—making several photographs of a scene at slightly different exposures—is often an indispensable technique for both amateur and professional photographers. It is especially important when transparency film is in the camera, because the margin for error is slim and the opportunity to make corrections later is limited.

The simplest reason for bracketing is a common one: The photographer, despite the fact that he has made careful exposure measurements and considered the lighting conditions with respect to the characterstcis of the film, is nevertheless uncertain as to what the correct exposure should be. It makes very good sense in this instance to make exposures at 1/2 f/stop above and below the estimated exposure. In extreme situations, it is advisable to make additional exposures beyond these limits.

Many professional photographers bracket exposures as a matter of routine, because it is essential to their careers and livelihoods that all their photographs turn out perfectly. The foregoing doesn't mean to imply that professionals don't know how to determine exposure and rely on the haphazard approach to photography. On the contrary, many subjective and creative factors may be involved in determining the median exposure in a bracketed series. The professional brackets exposures because it gives the client a range of slightly different-looking photographs from which to choose, because he may unexpectedly discover that slightly more or less exposure actually was preferable, and because he protects himself from technical problems beyond his control and from the errors of judgement which could happen to anyone.

Another argument favoring the practice of bracketing lies in the fact that often all the pictures in a bracketed series are acceptable. Consider the two sunset photographs by John D. Slack on plate VIII-C-12. The photo on the right was given three stops more exposure than the one on the left. Both pictures could

be considered to be properly exposed; any of the numerous intermediate exposures would also be acceptable.

USING COLOR CREATIVELY

Natural Light

Natural light, for the purposes of this discussion, is defined as the light coming from the sun. More importantly, it is "available light" in the sense that it exists in a given situation and the photographer either uses it "as is" or does not use it.

This section will cover the different qualities of light in terms of their appropriateness to various subject matter, a consideration that is perhaps the most important, but often the most overlooked, in natural light photography. Light, after all, is the medium with which photographs are recorded. If the available light is unsuitable, consider the option of waiting for it to change or to return to the scene at another time, if that is possible.

One quality of natural light is its harshness or softness, which the film records as high or low contrast. Several photographs in the color section of this book rely on this quality of light to provide most of the visual impact of the picture. Peter Keen's photograph of the oil slick on plate VIII-C-I says more about sunlight than it does about oil or sand. Similarly, the high-contrast effects of the pictures on plate VIII-C-2 rely on the harsh sunlight to tell their story. For the photograph in the middle of the page, for example, Keen deliberately chose the harsh overhead light of midday to emphasize the textures of the man's face and the fabric. Furthermore, the shadows cast by the files are practically invisible, due to the angle of the sun.

Joseph D. Cooper's photographs on plate XVII-C-3 illustrate a fundamental rule of outdoor portraiture: Avoid harsh overhead sun. Cooper made the better of the two pictures on an overcast day. The other picture would have been improved if it had been made at a different time, when the sun was not directly overhead. When this type of light cannot be avoided, reflectors should be used to direct sunlight into the shadows.

Other examples in the color section rely on soft, low-contrast light to achieve the desired effect. The pictures by Graham Finlayson and Tomas Sennett, on plates VIII-C-5 and VII-C-9 respectively, were both made by diffuse sunlight. Careful examination of the photographs, however, reveals subtle differences in the quality of light in the two photographs. Finlayson's photograph was made on an overcast day. There are no shadows, and the colors are soft and muted. In Sennett's photograph, patches of fog and mist diffused the light, and consequently the light is not quite as flat. While no real shadows are present, the photograph possesses lustrous highlights, particularly noticeable on the man and the horse. The grass in the foreground also has a certain luminous quality. In these situations, careful attention should be given to the position of the sun and to the position of these diffuse highlights.

Other qualities of natural light are related to the time of day: directionality

and color. These qualities also change with the time of year. For example, the sunlight one hour before sunset in the spring is different from the sunlight one hour before sunset in the winter.

The lighting conditions prevalent at the time of day were crucial to the two photographs on plate XVII-C-15. In Doubilet's photograph, the late afternoon sunlight slanting through the trees in the foreground contributes greatly to the pictorial impact. In Suzanne Hill's photograph, the angle of the sun produced the subtle tonal gradations. In both of these pictures, selection of the proper time of day was critical, especially since the scenes involved may have appeared fairly interesting at any time of day. The conscientious photographer will wait until the light reaches the point of maximum effectiveness. Douglas Lyttle's photograph of the beam of sunlight in Catedrale Santa Maria del Fiore on plate VIII-C-9 is the result of such careful planning. When the proper angle of sunlight is as important as in this picture, the photographer can't rely on accident, luck, or happy circumstance to produce the ideal photograph.

The other qualitative factor of light which relates to time of day is the color temperature of sunlight. Because the warmth or coolness of light often corresponds to the angle of the sunlight, the two are often considered in conjunction with each other. Generally speaking, the sunlight tends to be warmer at the beginning and end of the day than at midday. A color temperature meter will verify this fact in quantitative terms. Frank Herholdt's photographs on plate XVII-C-9 demonstrate the importance both lighting angle and warmth contribute to the overall mood of a photograph. Both photographs would have been entirely different if they had been made at noon.

Struan Robertson's photograph of the cattle on plate XVII-C-17 is another illustration of the contribution of the angle and color of sunlight late in the day. Robertson decided to backlight the subject, emphasizing the shapes of the cattle and the airborne dust.

The color of the late afternoon sun is an important ingredient in Robertson's other photograph on the same page. The muted pink sunlight provided a delicate contrast to the shadows on the ground. Patrick Thurston's photographs on plate VIII-C-8 are excellent examples of the changing color of sunlight. Compare the two photographs of St. James Park. The time of day and atmospheric conditions contributed to make these photographs entirely different, although their subject matter is nearly identical. The Edinburgh skyline, of course, would not have looked the same at any other time of day.

Composition with Color

Human perception relates colors in important ways. The warmer colors, for example, such as red, orange, and yellow, seem to advance toward the viewer and the cooler colors seem to retreat. Carl Purcell, in making the photograph at the bottom of plate VII-C-4, used this fact of color perception, as well as the foreshortening properties of the wideangle lens, to draw the flowers into the foreground. Imagine how different this picture would be if the flowers were blue.

Our perception of specific colors is also influenced greatly by the colors which accompany them in the photograph. When a color adjoins a neutral gray tone,

for example, the gray seems to take on slight cast of the complementary color. When a pale hue is placed next to a complementary color, the saturation of the pale hue seems to be increased. The visual effect in both instances is increased color contrast.

The juxtaposition of complementary colors often is the primary factor in the making of a photograph. Robert Pastner, for instance, on plate III-C-4, included small areas of color to add interest to the photographs of otherwise dull industrial situations. In Joseph Abbott's photograph on plate XVII-C-13, the complementary color of the woman's yellow dress added depth and interest to an otherwise flat and monochromatic scene.

Rather than using a small area of complementary color, Dan McCoy used broad areas of deeply saturated colors in a flat perspective to achieve dramatic visual impact on plate VII-C-6. In the center of the picture, the red, blue, and yellow areas meet along sharply defined lines. The tree trunk, which coincides with the left side of the yellow patch (purposely), leads from the red area up to the green mass of the leaves. McCoy carefully included small portions of the sidewalk and the roof of the building to contribute a slight feeling of depth. Had he excluded the man, the sliver of sidewalk, and the patch of roof tiles, the entire composition would be extremely flat and abstract.

In other photographs on plates VII-C-6 and VII-C-7, McCoy demonstrates what can be accomplished with only one or a few colors—a "limited palette." The photograph of the Death Valley sand, for example, uses shadows to emphasize texture. The successively increasing widths of the bands add perspective. The photograph of the horses contains only two tones, yellow and black. In the haystack picture, yellow is the dominant color, offset by small white highlights and a small portion of blue sky. McCoy's pictures on plate XVII-C-20 also use a limited number of subdued colors, and rely on soft, subtle lighting to achieve their effect.

Achieving Special Effects

Because each color film reproduces color differently, and no film can claim to achieve absolutely "true" color reproduction, all color photography is, in a sense, "false." Here, "false" color is defined as that which is deliberately distorted, and represents a deliberate departure from reality.

Pete Turner is one of the photographers represented in this book who employs many different techniques to arrive at unusual effects. One technique involves the use of transparency film in the "wrong" type of light. Turner's photograph at the bottom of plate VII-C-15 was made on Type A Kodachrome, which is balanced for 3400K. (The product is now called Kodachrome 40.) Daylight, which is about 5500K, is excessively blue for this emulsion. One of the Type B Ektachromes (3200K) would have produced a slightly bluer effect. Incandescent light produces a warm, orange cast on photographs made on daylight-balanced film. In any of these applications, filters of the 82-series (pale blue) or the 81-series (pale amber) will adjust the color imbalance to any desired degree.

Tomas Sennett's photograph on plate I-C-3 is an excellent example of the

creative possibilities inherent in selecting a particular emulsion in "mixed" light. Sennett used Type B (3200K) Ektachrome. Because the dancers appear to be rendered naturally, it is clear that they were illuminated with tungsten theatrical lighting. The sunset, however, appears bright blue.

While filters are normally used to "correct" the existing light so that it will correspond to the color balance of the film in use, they may also be used to introduce false color. Numerous examples of this technique appear throughout this book. Pete Turner's photographs on plates III-C-1, VII-C-14, and VII-C-15 are examples of this technique.

Also noteworthy is Turner's use of the bicolor split filter on plate VII-C-14. The division between the two filters is hidden by the silhouette of the vertical pole. Other split filters have one clear side. They can be used to introduce color to the sky, or to any part of the picture.

Prisms and diffraction gratings can be used in front of the lens in the same manner as filters. Many different "special effects" attachments of this type are available, and their results vary greatly. The photographs on plate XVI-C-2 give an indication of this diversity. Peter Millan's photograph was made with a scored glass filter which created the diffraction spokes centered on the highlights. Other attachments of this type produce single line, rather than the crossed lines seen here. Richard Tucker's photograph was made with multi-faceted prism attachments. The multiple-image effect changes as the lens is stopped down. Homemade devices, such as those used by Peter Keen on plate XVI-C-2 and Al Satterwhite on plate XVI-C-1 can also create unusual effects.

Another technique for creating unusual effects involves multiple images. Slide sandwiches and multiple exposures are two different methods of creating multiple images.

When two or more transparencies are sandwiched together, the relatively opaque areas of any of the transparencies will entirely obscure all detail in the resulting composite photograph. The less dense areas will permit superimposition of the various images. To make the photographs on plate XVI-C-13, Peter Millan used the photograph of the window frame to obscure detail from each of the various slides. The window frame, therefore, appears to be in the foreground of each of the photographs. Al Satterwhite's sandwiches on plate VIII-C-13 produce silhouetted birds which obscure various areas of the enlarged image of the sun.

When multiple exposures are made in the camera, either of the original subjects or other transparencies photographed with a duplicating setup, the rule is changed: The darker areas of the subject become available as space for additional detail from subsequent exposures. This is evident in Pete Turner's photograph at the bottom of plate III-C-1. Turner added the image of the eye to the dark area of the sky. Peter Miller's photograph of the ski jumper on plate XVII-C-8, however, could only have been made by sandwiching. Otherwise, the exposure of the lighting instrument would have obliterated almost all detail of the skier.

A third method, printing several images on one sheet of color printing paper, follows the same rules as slide sandwiching: light areas provide room for subsequent images.

Earlier, the differences between transparency and negative films were discussed in general terms. Reversal films are first developed to yield a negative. The unexposed, undeveloped parts of the emulsion are then fogged and redeveloped. Color dyes are then formed in these redeveloped regions and a positive color image is formed. If the reversal procedure is eliminated by developing the reversal film in conventional negative chemistry, a color negative will form. This negative will not resemble conventional negatives because it won't have the familiar orange mask. Therefore, a print made from this negative will have distorted color.

Infrared color slide film is sensitive to infrared radiation, which is invisible to the eye, and to visible light of the red-yellow end of the spectrum. A yellow filter is recommended for use with this film, although a wide variety of filter combinations can be used to achieve different effects. Examples of the effects possible with this film are on plates I-C-6, XV-C-6, and XVII-C-14.

The photographs of Bob Nemser and Bill Jorden on plates XVI-C-8 through XVI-C-11 combine several of the techniques mentioned here. The captions of specific pictures furnish technical details.

Photographing in Color

The wide variety of materials and techniques available to the photographer working in color offers a limitless potential for creativity. The purpose of this book has been to help the photographer make decisions regarding film selection, exposure, lighting, and composition. Many of the procedures for achieving special effects have also been described briefly; you are invited to use these suggestions as starting points for your own experimentation.

* * *

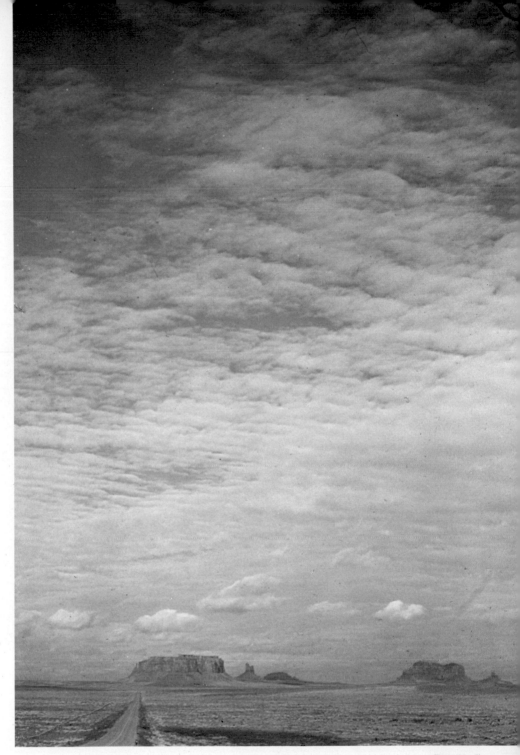

Dan McCoy

The ground details serve mainly to give scale and depth to the patterned Monument Valley, Utah, sky. The shortest of the telelenses, the 85mm, was used for selective composition.

Joseph D. Cooper

The zoom 80-200 was used for selective composition. A shorter focal length at closer shooting distance would have covered the same area, but then flattening of composition would have been lost.

Larry West

Chiricahua National Monument, Arizona. Late day lighting, filtered by trees, creates shadowless tinted effect. 35mm f/2 lens at close range gives foreground prominence with wide coverage. f/11, ½ sec. on tripod.

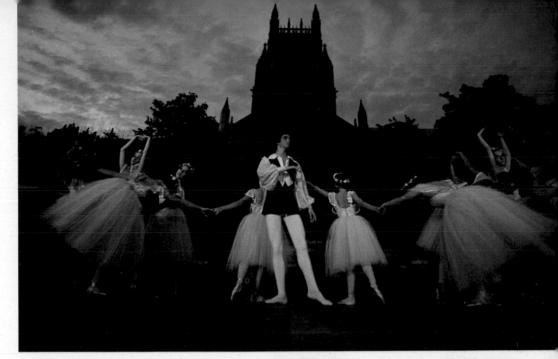

Tomas Sennett

Red dusk converted to blue using type B (tungsten) High Speed
Ektachrome. 20mm lens, remote control. Sennett crawled to cam-
era for exposure bracketing.

Desired scale relationships of Angkor Wat foreground and back-
ground, with exclusion of side details, achieved with 105mm f/2.5
lens. 1/125 sec f/6.3 Kodachrome.

Suzanne G. Hill

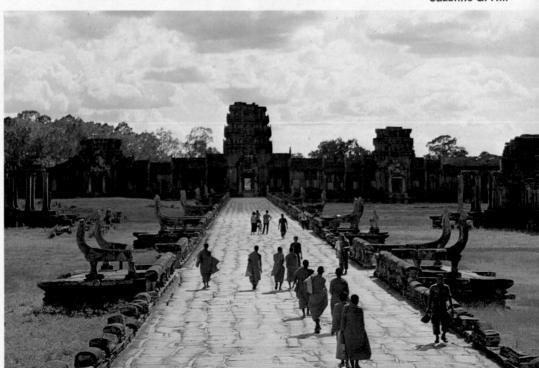

Grayham Finlayson

Versatility: Portrait of Richard Hughes with 85mm *f*/2 for selectivity, window lighting. Creative use of 7.5mm *f*/5.6 Fisheye compared to 50mm shot of Goodyear airship. (Foregoing courtesy Daily Telegraph Magazine.) Old fire brigade uniforms, 28mm for depth; courtesy Sunday Times Colour Magazine.

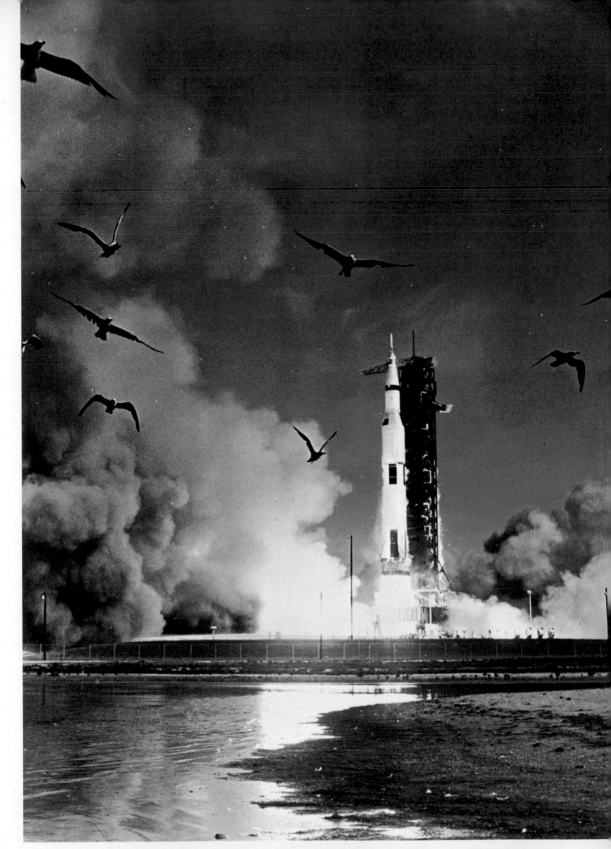

John D. Slack

Apollo rocket lift-off. Exposure was for light from rocket which is two stops under normal daylight. Camera on tripod fired from remote position, sound trigger, F36 motor 50/2 lens at f/8, 1/1000 sec. Ektachrome-X.

Gerry Cranham

The creative sports photographer strives for the touch of difference in typical scenes: framing the subject (motorized Nikon F, zoom 80-200); a special film for creative color (Kodak Ektachrome Infrared, zoom 80-200) a slow speed to capture motion (20mm f/5.6, 1/15 sec.)

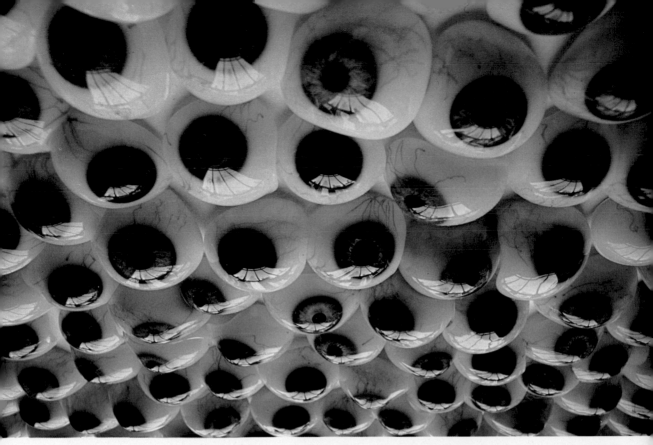

Pete Turner

Lens and light are starting points. Field of glass eyes photographed in studio with north light, CC110B filter, Kodachrome IIA, 20mm lens for foreground prominence, picture inverted for impact. Beach scene exposed in Denmark, 105/2.5 lens, 38A filter, and Kodachrome IIA. Slide copied and run through camera again to double expose eye using 55mm Micro Nikkor.

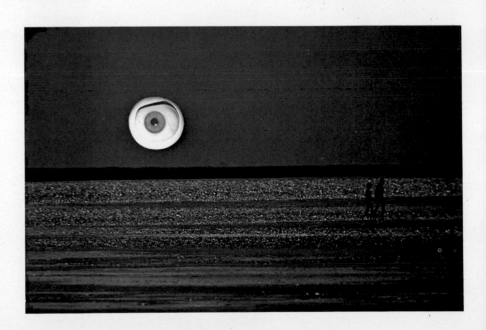

Francisco Hildago

Color, viewpoint, and movement are the carnival, all Ektachrome. Masked figures, above, with 500/8 mirror lens hand held 1/15-1/30 sec! Again, below, slow hand-held speed 1 sec. wide open, 50/1.4, yields ethereal character.

Critical focusing and mastery of shutter release action are evident in this masked portrait. 50/1.4 at f/5.6, 1/30 sec.

Sensation of movement heightened by slow shutter speed. Drama heightened by contrast of figures against dark background.

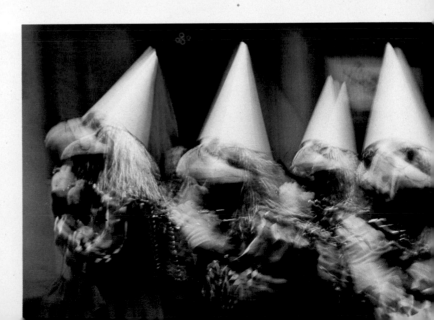

Assignment: silk purse from sow's ear. Solution I: 28mm lens and camera slant for exciting perspective; red dress for color spot. Solution II: Splash of red light on otherwise drab rails, bars, and tubing; 105mm lens for gradual perspective fall-off.

Robert Pastner

Color additives: fashion model Clementine shot through hole in aluminum foil lit up by blue spotlight 105/2.5 lens.

Assignment for Seventeen Magazine: "Portray six different shoes and stockings. Do so arrestingly. Unify." (original used as two page spread.) 105/2.5 lens.

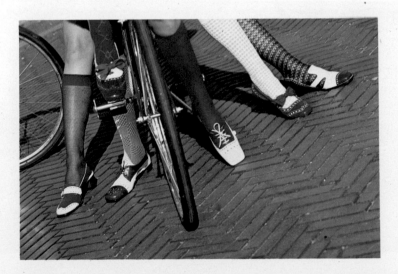

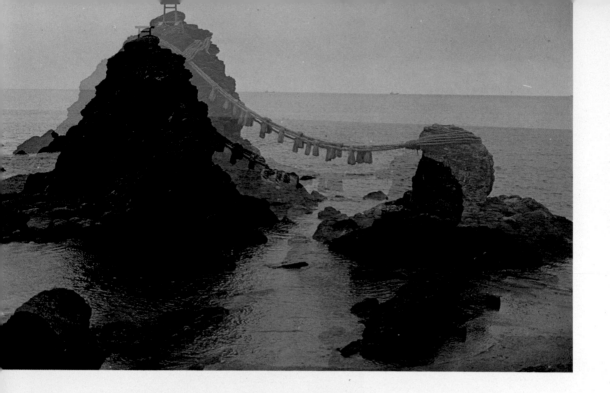

The touch of difference: (1) Oft-photographed wedded rocks shrine, Futami Bay, Japan, double-exposed with different-colored filters, 105/2.5 lens. (2) 28mm lens held close to hose of Douglas DC8 plane to achieve humorous perspective effect. (3) 43-86 zoom shot of fashion model Clementine to achieve double-exposure effect with one exposure.

Robert Pastner

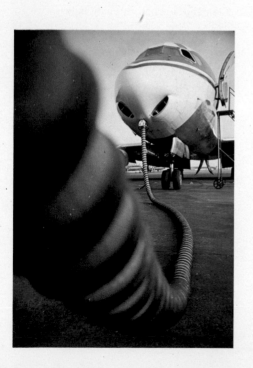

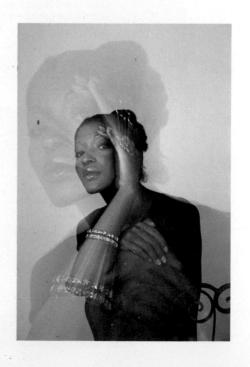

Gerry Cranham

Out-of-focus globs of bridge lights form a pattern against the dark backdrop of night. 85/1.8 lens wide open 1/30 sec.

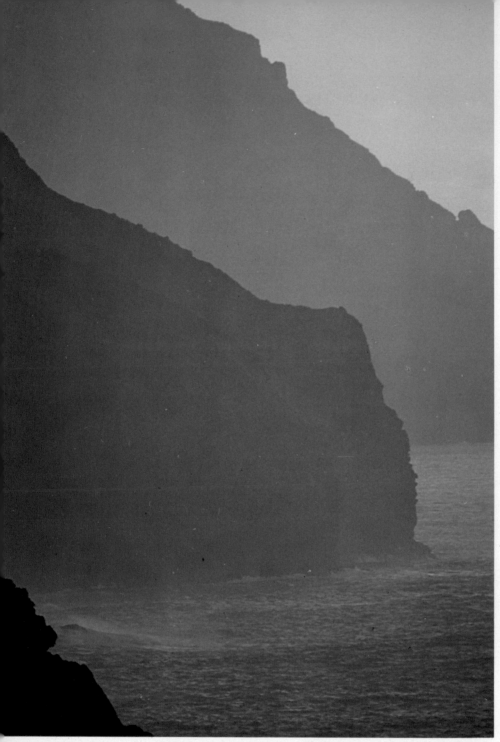

Peter Miller

Many scenes offer a range of selective possibilities. A single lens may suffice, provided one is able to move toward or away from the subject. This picture of Napali Coast, Kawai, Hawaii was made with 500/8 lens. See facing page for selective views with other focal lengths.

Peter Miller

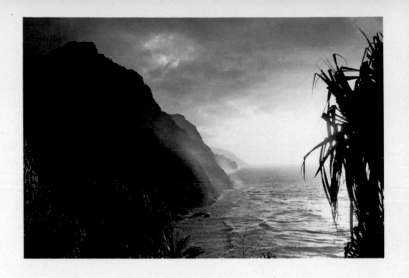

Wide-angle view with 35mm lens.

Selective views with 80-200/4.5 lens.

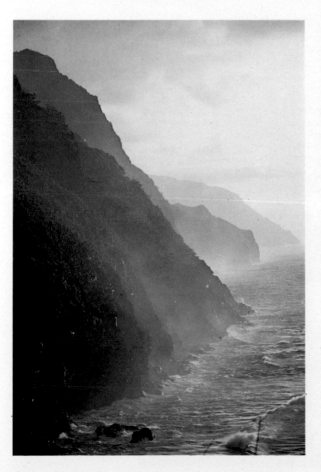

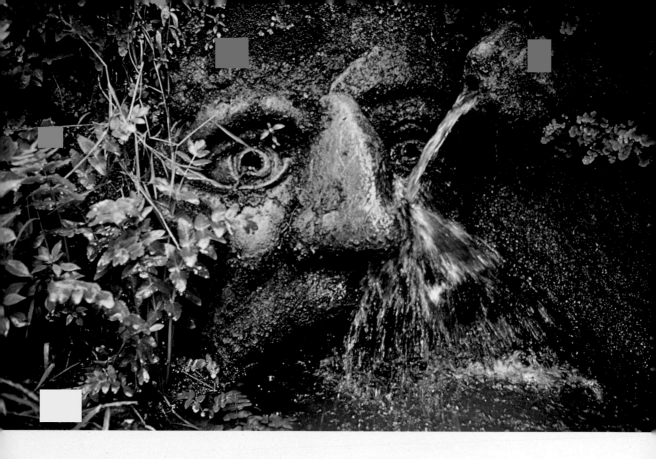

Stone face in fountain, Tivoli Gardens in Denmark. Up close it's a wide-field detail. From afar, it's a mosaic. Nikkormat, 35mm lens, Kodachrome II.

Carl Purcell

Wide-angle lens permits moving in close to give prominence to foreground while scaling down background. Brilliant red roses focus attention and lend depth. Nikkormat, 24mm lens. Kodachrome II.

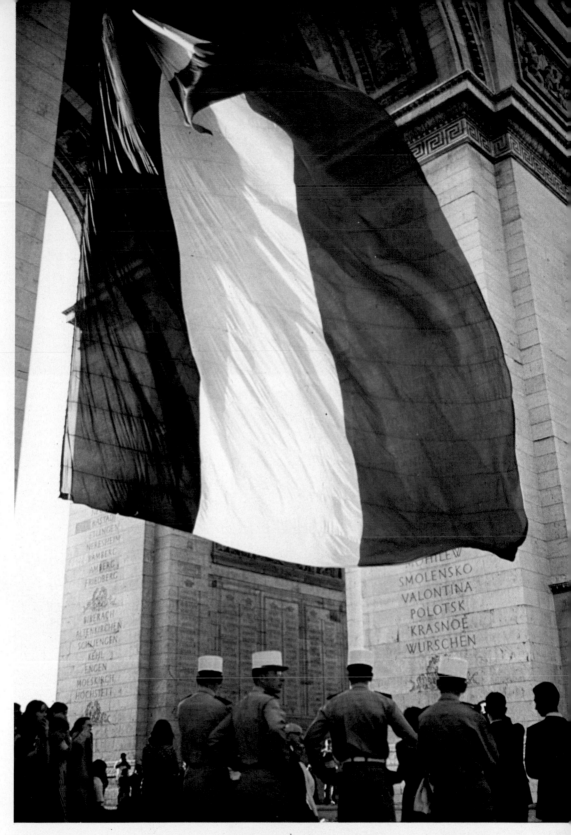

At the Arc de Triomphe the small figures are set off against the simple mass of the flag.
28mm lens.

Carl Purcell

Many of McCoy's compositions are based on the juxtaposition of tonal and geometric mass. Detail from Portuguese village (for National Geographic Magazine) combines the two. Nikon F, 200/4, f/5.6 at 1/125 sec., skylight filter.

Dan McCoy

Sand, Death Valley, brings out receding perspective in combination with shadings from natural light, Nikon F, 55mm Micro Nikkor stopped down to f/32 on tripod, 1 sec., Kodachrome II.

The small bit of sky enables the haystack mass in Italy to predominate, thus putting emphasis on textural composition, subtly rendered by overcast light. Nikon F, Micro Nikkor 55/3.5, f/11 at 1/60 sec., Kodachrome II.

Dan McCoy

Two horses against the infinite sky—a reverse composition. Seen while driving through Virginia. Nikon F, old 180/2.5, late day sun, tripod, f/40, 1/30 sec., Kodachrome II.

The subject (Prof. John Wheeler, Princeton, physicist) is deeply involved in such cosmic matters as black holes in space. Problem: achieve cosmic quality. Solutions: use 20/3.5 close for perspective effect; invert picture to enhance. Nikon F, f/8, 1/60 sec., Kodachrome II.

Dan McCoy

Natural mosaic after Seurat. Zion National Park, Utah, late afternoon. UV filter, Kodachrome II. Nikon F, old 180/2.5, f/32, 4 sec. on tripod.

Tomas Sennett

300mm lens pulls in background. Sennett spotted horse while driving, went back and set up scene.

 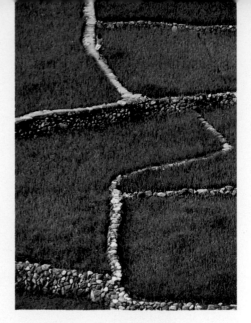

Wagon seen through window of Hilton Hotel, Phillipines, and "grabbed" with 300mm lens for desired scale. Glancing light creates single point of attention in context. . . . Stone fences picked off from top of mountain using 300mm lens for selective composition.

Tomas Sennett

Soft lighting best for texture rendition. Humorous configuration of driftwood, resembling horse's head. Dull day, Micro Nikkor 55/3.5, Kodachrome II, f/4; 1/60.

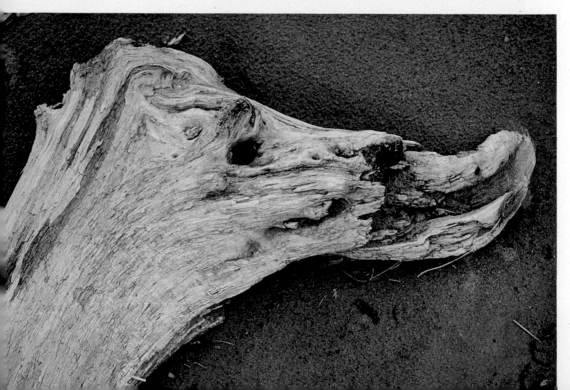

To increase depth of field, front standard of Bellows PB-4 with Bellows 105/4 lens tilted downward, base parallel to ground. Overcast day reduces contrast, fills in shadows. Kodachrome II.

Larry West

Douglas T. Mesney

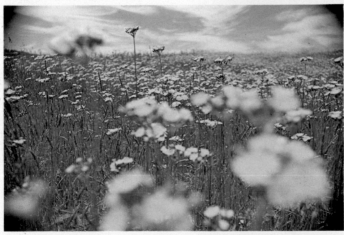

Richard Tucker

Two interpretations of same kind of subject matter. Mesney "planted" motorized Nikon FTN 20/3.5 low and fired remote, f/16, 1/250 sec., focus toward rear; after-manipulation of color. . . . Tucker used 24/2.8 lens at f/16 for maximum depth near to far.

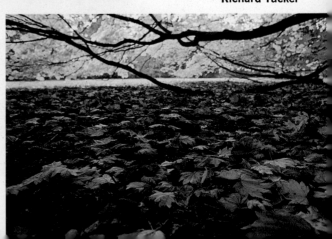

Composition in flat plane. Elements: repetition of geometric form, color spots against neutral background, contrast of details against simple mass. 85mm lens used for flattening effect.

Composition elements as above, except for background. 200mm lens used to select critical plane of primary image.

Grayham Finlayson

Joseph D. Cooper

Spot of color adds interest center, contrast with neutral or dull patterns or backgrounds. Decorative objects photographed with 80-200 zoom for flattening effect and to maintain relative size of plates.

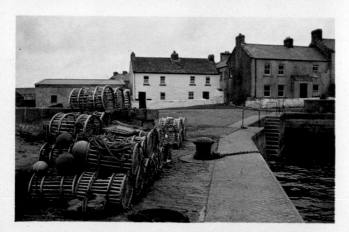

Vernon Sigl

Waterfront scene, wide-angle lens used to pull out foreground. Colored buoys add vibrant element. 28mm. lens at f/5.6.

Two nuns framing Statue of Liberty as nominal center of interest for total scene unity. 50/1.4 used at f/2, 1/500 sec.

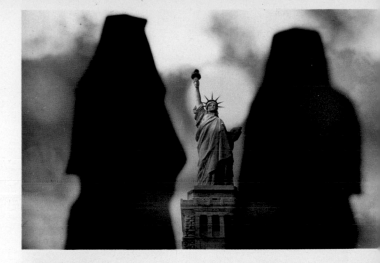

"Dead End" sign, Brooklyn docks. Red splashes link with deepening sky to frame buildings in depth. 80-200mm Zoom Lens, 1/30 sec., at 200mm extension, f/4.5.

Francisco Hidalgo

Selective focus defines drum sharply while out-of-focus fingers convey mood. Hands framed as center of interest by dark areas. 35mm lens.

Ian Bradshaw

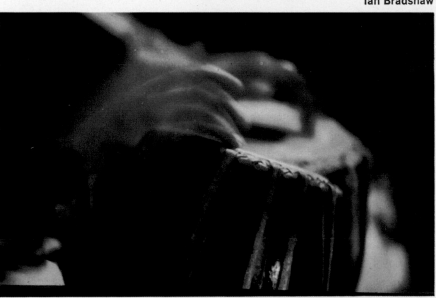

"The All-American Women." Perspective illusion: 20/3.5 lens controls figure sizes carefully placed, rear-lit background cleared of size scale clues. Women lit by electronic flash. Kodachrome II, 21 filter.

Pete Turner

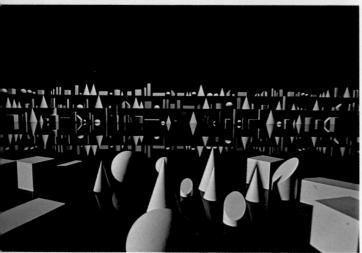

"Time-Space." Foreground / background relations controlled with 20/3.5 lens. Rear figures on black glass surface. Front group "painted" with light blue gel. Electronic flash.

Some of Turner's creative abstractions: form, color, light and optical glass.

"New Age." High-voltage materials in Sweden. Color created with split filter 25/15. 85mm lens. Kodachrome II.

"Descent." Dramatic effect enhanced by 15 filter. Helicopter dropped Turner into area near Hawaiian volcano and was then radio-directed into position. 200mm lens.

Pete Turner

"Ibiza Woman." Blue tone through use of unfiltered Kodachrome A in daylight, island of Ibiza, Spain. 50mm lens.

Pictures in umbrella village, Thailand. Pattern in a close-up detail (135mm lens, f/8, 1/125 sec.). Pattern in a grouping of umbrellas made with slightly shorter lens (105/2.5, made at f/6.3, 1/125 sec.). Both Kodachrome II.

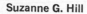
Suzanne G. Hill

Corner of Buddhist temple, Thailand, versatile 50mm lens used close excluded competing details. Kodachrome II, f/4, 1/125 sec.

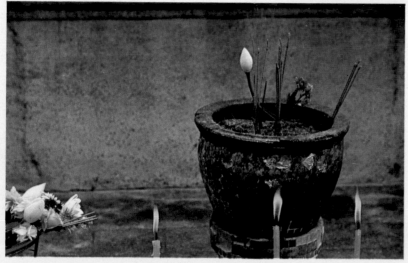

Oil slick reflecting hot, brilliant, harsh, difficult desert sun keynoted story on oil sheiks of Persian Gulf. Kodachrome II rated up at ASA 32 for better saturation. 35/2.8 exposed f/11 at 1/125 sec.

Peter Keen

In absence of sun, subdued tones come through unsaturated color, but rich in texture. Guyanian child on sugar plantation. 105/2.5 lens, f/5.6, 1/60 sec., Kodachrome II rated ASA 32 for deeper tone.

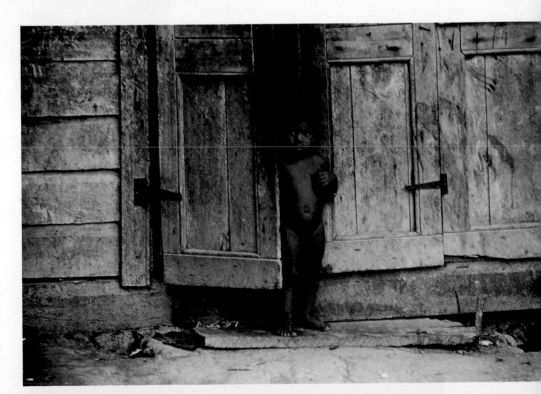

Sun directions: Above—Side light from small window of wattle hut on Benounou, Keen's Touareg guide in Sahara desert, 105/2.5 wide open, 1/15 sec. Right—Harsh, merciless sun catches Benounou covered with flies 105/2.5 at f/8, 1/250 sec. Below—Sun straight into lens over edge of great sail of felucca sailing boat, river Nile. 24/2.8 at f/16, 1/250 sec. All Kodachrome II, rated 32 for slight underexposure.

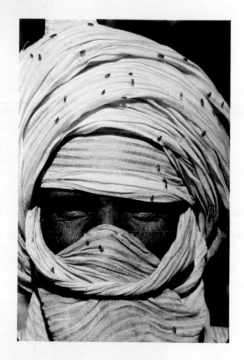

Peter Keen

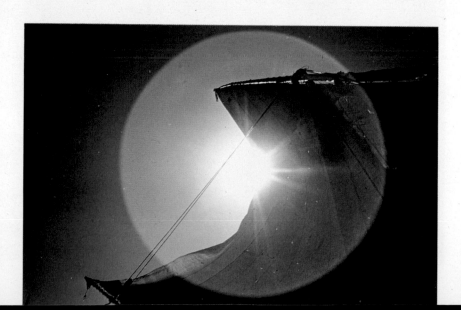

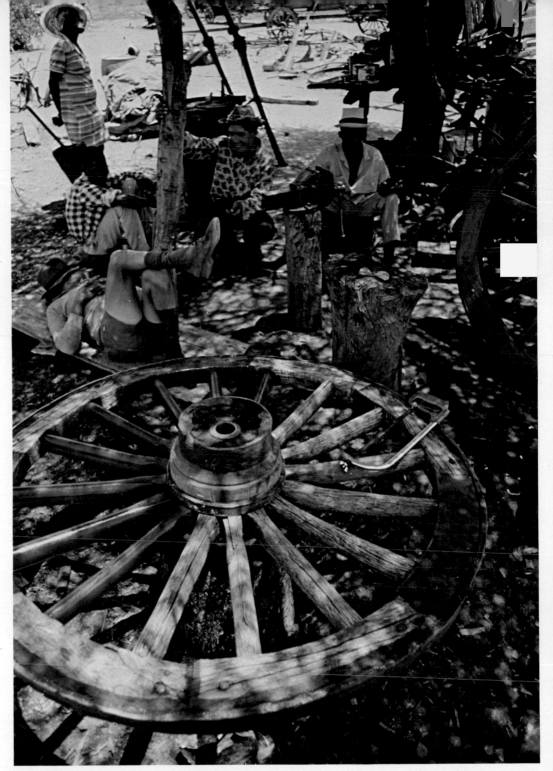

Struan Robertson

Lunch time at Wheelright's, Mochudi, Botswana. Contrasts between sun and shade; compromise favoring latter which dominated scene. For composition impact, 24/2.8 was used close to wheels, magnified relative to men and wagon. Ektachrome-X.

Joseph D. Cooper

Al Satterwhite

Creative problems in coping with non-standard lighting. Left, backlit effect, exposure for faces, 105/2.5 lens. Right, side lighting, exposure for front of face, 105/2.5. Below, no sun for monochrome effect, winter, New Forest, England, 85/1.8.

Graham Finlayson

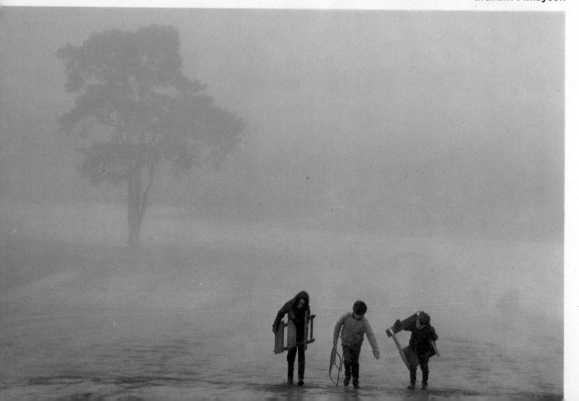

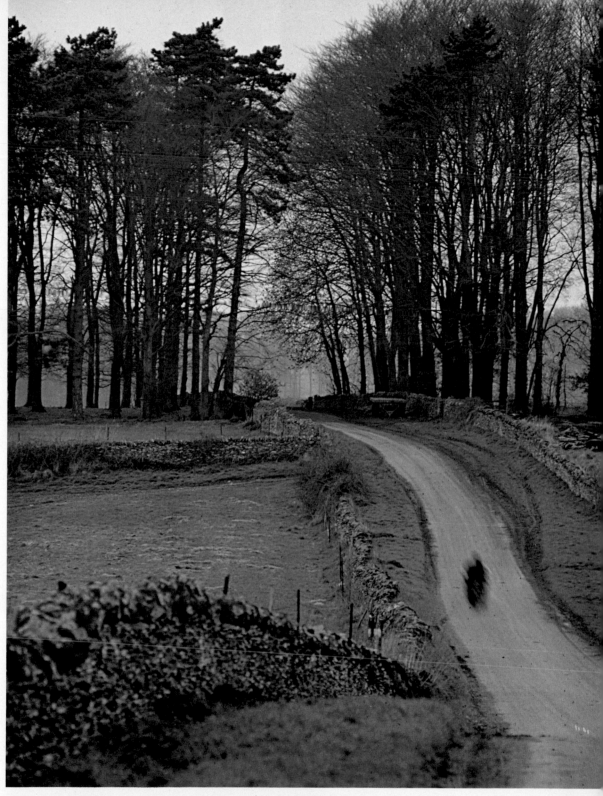

Graham Finlayson

Slow exposure on dull day caused blurring of cyclist, adding to mystic effect of soft, sha-
dowless pastel. 85/1.8 at 1/8 sec. Ekatahrome X. From book, *Just a Few Lines*.

Each color film has its own characteristics. Top, Fujichrome R100 has warm tones, 24/2.8 lens. Below it, Ektachrome-X, Zoom 80-200. Compare stone walls.

Joseph D. Cooper

In this pair, top picture with Fujichrome R100, bottom with Ektachrome-X, both Zoom 80-200.

Patrick Thurston

Long ship's light, Cornwall, Land's End, evening shot on tripod, pink filter. 135mm lens to bring in background.

Patrick Thurston

Pastels from the edges of light. Above, St. James Park, London. Below, Edinburgh, Scotland at night.

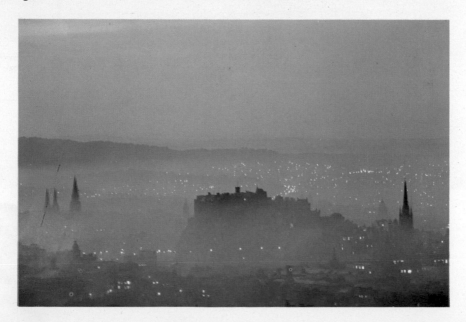

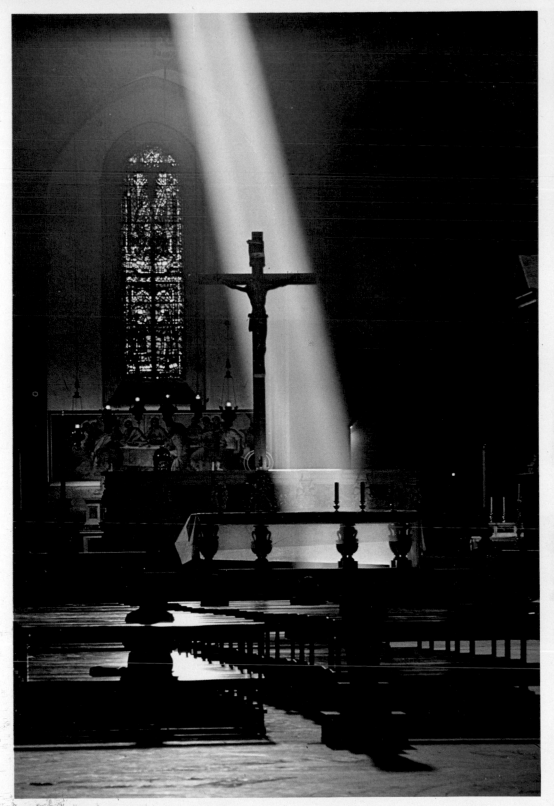

Douglas Lyttle

Tripod essential, arranged in advance for this dramatic scene in Catedrale Santa Maria del Fiore, Florence. Mirror flipped up first, then shutter released, about 1 sec. f/4 with 105/2.5 Kodachrome II.

Douglas Lyttle

Pocket of light and human interest. Street market, Vienne, France. 105/2.5 about 1/60 f/2.8-4, Kodachrome II.

Indoor pocket of light. 135/3.5 wide open, 1/15 sec., hand-held. High Speed Ekta-chrome.

Joe DiMaggio

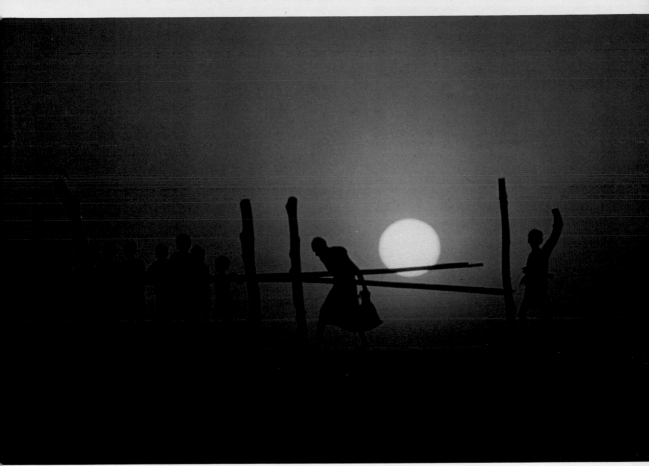

Carl Purcell

Sunset in Bangladesh. The low sun magnified with 300mm lens. Sky reflected deep rays of sun. Figures on footbridge provided silhouetted framing. Kodachrome II.

Sunsets and sunrises combine richness of color and composition. To bring out deep color, sky readings must be adjusted one or two stops less, thus sacrificing foreground detail. Lower sun yields deeper color. Clouds serve as filters, reflectors, and framing materials. Water reflections open foregrounds. Indirect illumination may add special effects such as through silhouetting or spread of skylight from sun that has gone beyond horizon or ground objects. Big suns are lowest in sky and are enlarged with long lenses.

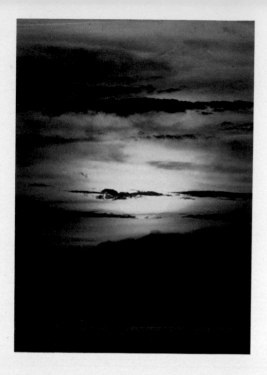
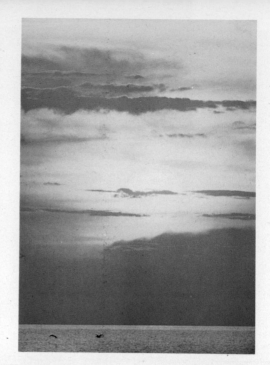

"Normal" exposure reading yields pale sunsets and sunrises. Cutting exposure deepens sky color, but sacrifices foreground detail up to a point of no further loss. Thereafter, cutting exposure is mainly for sky control as desired. 600mm Tele-Nikkor both exposures; left f/5.6, 1/250; right f/11, 1/500 (Nikon School).

John D. Slack

Long lens magnifies size of sun and excludes foreground detail, usually darkened. Small picture made with 50mm lens, comparison with 300mm. (Nikon School).

Bill Campbell

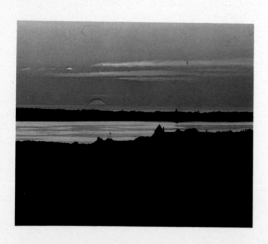
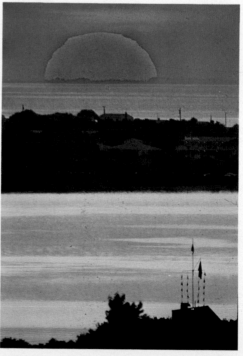

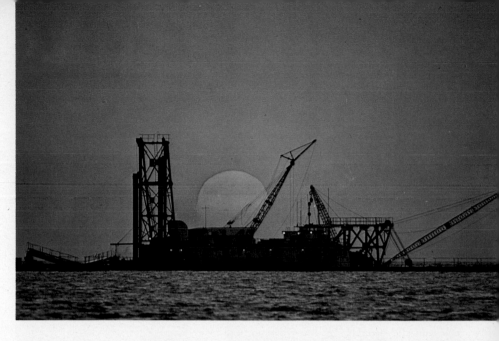

Dredge, Gulf of Mexico, frames low sun further enlarged with 500/8, Kodachrome II.

Al Satterwhite

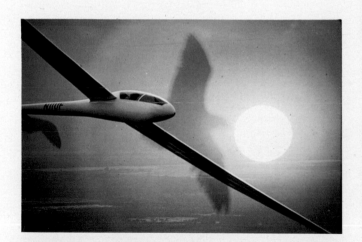

Creative output of two lenses combined in sandwich and copied. Glider with 300mm; sun and bird with 500/8. Kodachrome II.

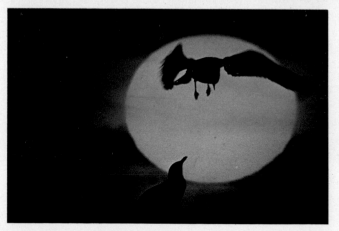

Another sandwich: sun with 1000mm mirror lens and birds with 500 mirror lens. Kodachrome II.

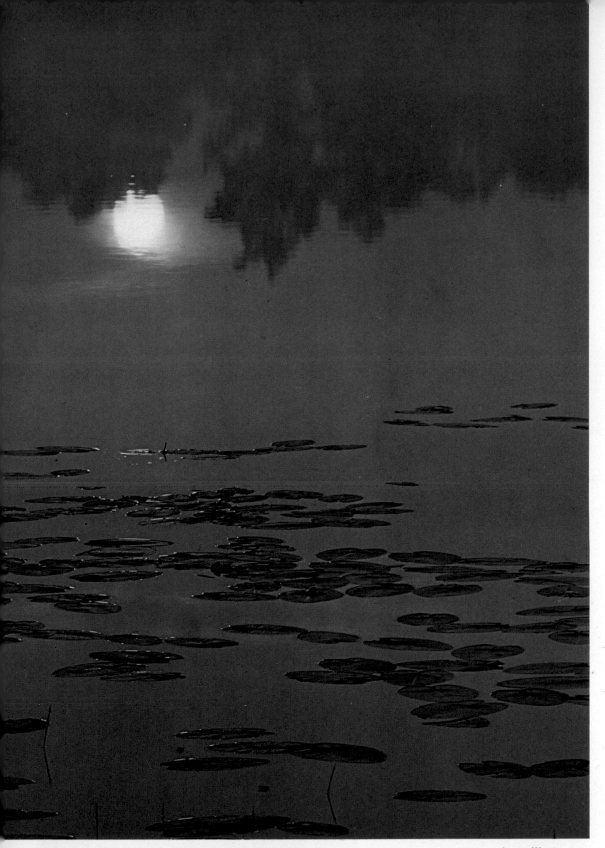

Larry West

Sunrise reflection in bog lake. Note how water surface objects pick up emerging sunlight. 200/4 at f/16, 1/8 sec. on tripod. Kodachrome II.

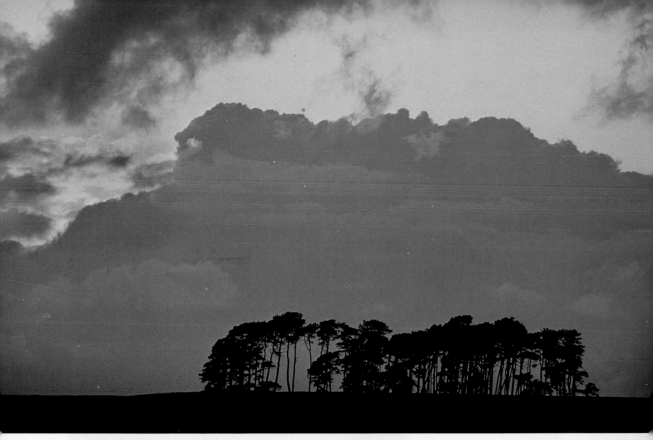

Graham Finlayson

"Sun-sprayed" clouds without visible sun. 200/4 used to emphasize parallel formation clouds and trees. (For Standard Oil of New Jersey) Kodachrome II.

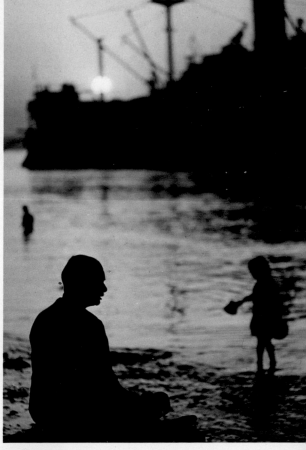

Indirect sun rays. Holy man at prayer, River Hoogly, tributary of Ganges. 105/2.5 wide open, 1/125 sec. Kodachrome II rated 32.

Peter Keen

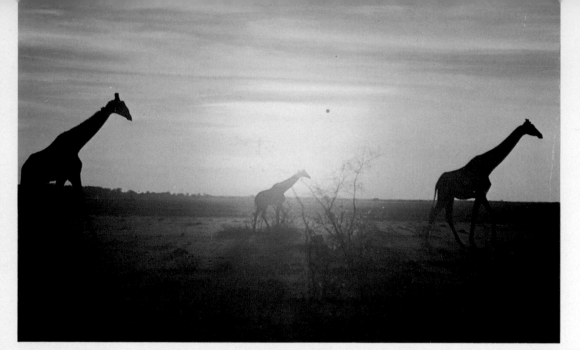

Struan Robertson

The sun, not yet very low, will "burn" out objects in path, especially if sun is diffused.

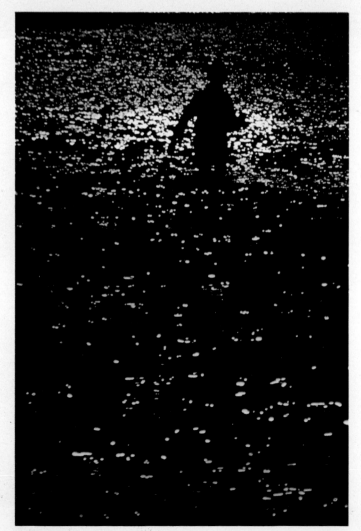

To bring out highlight and catchlights, while losing details, underexposure on Kodachrome II at f/16 and 1/1000 sec. with long lens.

Peter Millan

Rejog—a trance dance—Java. Heiland 7 camera as trigger and fill light; Graflex 4 and bare tube at left and high; Graflex 4 with regular reflector high and to right. 35mm lens, High Speed Ektachrome.

Dean Conger

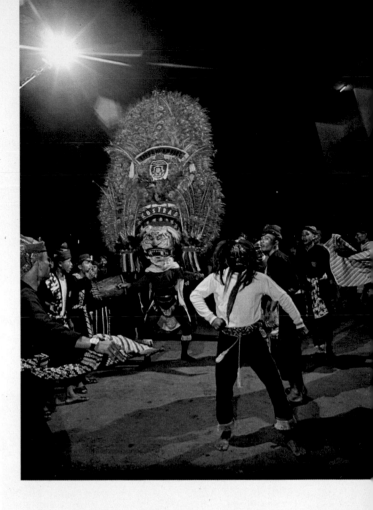

Additional details these pictures in flash text.

Gamelans played at Jogjakarta. Multiple flash, main source bare bulb "stick light" triggered by Heiland 7 at camera, fill light Heiland 4 bounced off ceiling. 24/2.8 lens, Kodachrome II. For National Geographic.

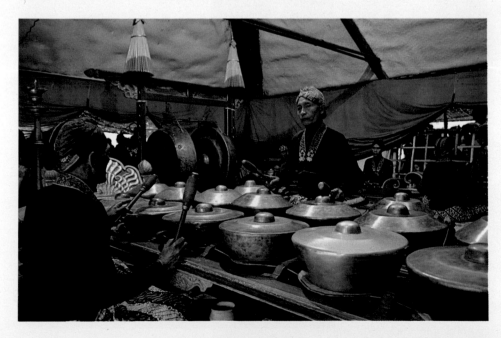

IX-C-1

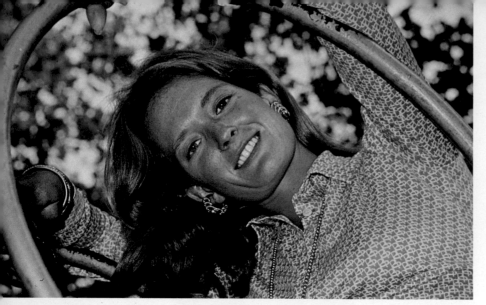

Stan Menscher

"Synchro-sunlight" or outdoor fill flash. Flash fills shadows against background of natural light. (Nikon School)

Grayham Finlayson

"Lord Nelson and Lady Hamilton" staged in Wheeler's, St. James'. Umbrella-reflector flash in foreground balanced with daylight from rear windows. 35mm lens. Kodachrome II.

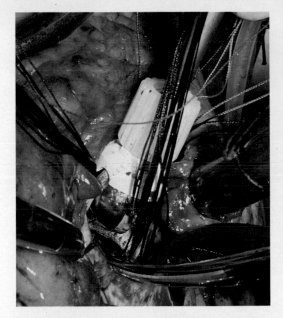

Camera-mounted flash. 105/2.5 lens cali-
brated in quarter stops for distance control.
(See black-and-white section following.) Ser-
ies showing removal defective aortic valve,
replacement by metal ball. Top, valve re-
moved, E2 ring f/16. Side, special holder
locating prosthesis, two E2 rings, f/32, valve
sutured into place, three E3 rings, f/16-22,
Bottom, a mitral valve prosthesis with sutures
attached, to go into place, one E2 ring f/16.
Ektachrome-X.

Jean Gauthier

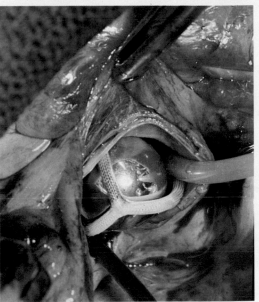

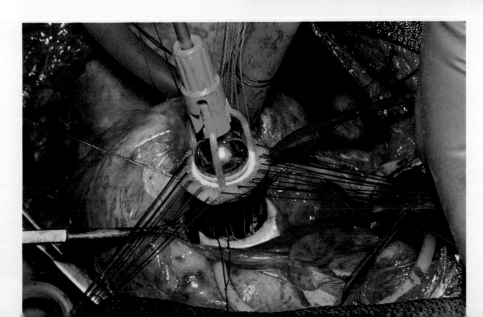

Patrick Thurston

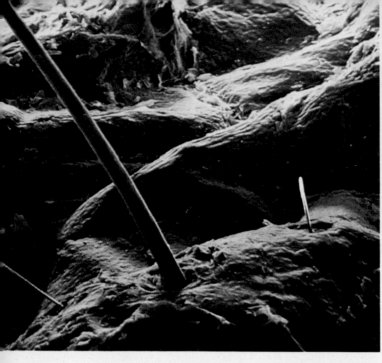

Human skin and hair

Bug from woodpile

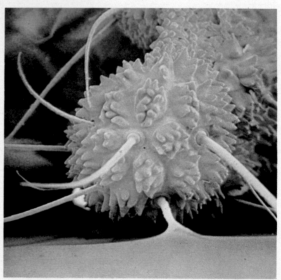

Photographs of stereoscan microscope screen, 4 in. square (ca. 10cm²). Color obtained with filters and through reversing screen image from positive to negative. (Stereoscan screen like slow-scanning TV screen). Micro Nikkor 55/3.5, Kodachrome II.

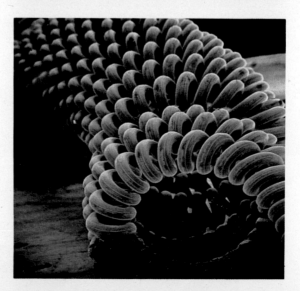

Electric light bulb filament

Spacebush swallowtail larva, open shade, 105/2.5 on Bellows PB-4, f/11, ½ sec.

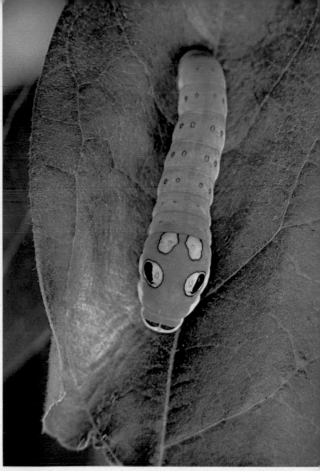

James A. Arnett

Larry West

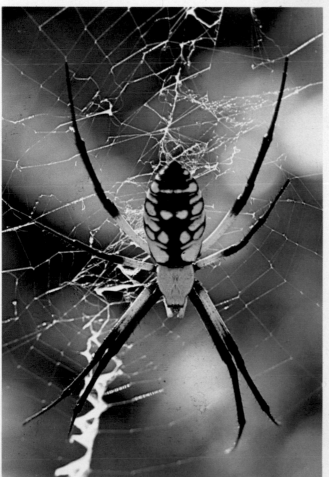

Spider illuminated from rear. Shot with 105mm Bellows Nikkor and PB4 Bellows, 1:4 magnification. Kodachrome II, f/11, 1/30 sec. (Nikon School).

Ian Bradshaw

Double exposure of model Marsha Hunt and painting. 35/2.8 lens. Basic rule is to divide total exposure load on film by number of exposures to get individual exposure.

Sandwich technique of double exposure calls for transparencies of complementary density due to additive effects. Golfer with 35/2 on Kodachrome II, f/8, 1/125 sec.; face with 85mm lens on Kodak Tri-X.

X-C-4

Al Satterwhite

Aquanauts, Tektite-2, Virgin Islands, 1000-watt flood, Nikon F, 24mm lens in Ikelite plexiglass housing, Ektachrome-X.

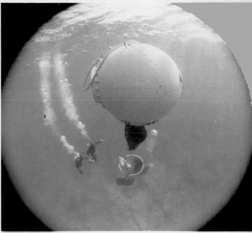

Archeologists going to decompression chamber near 150 ft. deep old Roman wreck, Bodrum, Turkey. Nikonos, Fisheye f/5.6 in Schulke adapter.

Flip Schulke

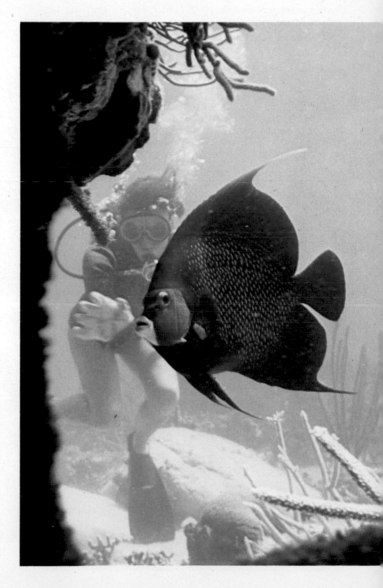

Female aquanaut, Tektite-2, Virgin Islands, 1000-watt flood, Nikonos, old 21mm Nikkor lens in Schulke adapter, Ektachrome-X.

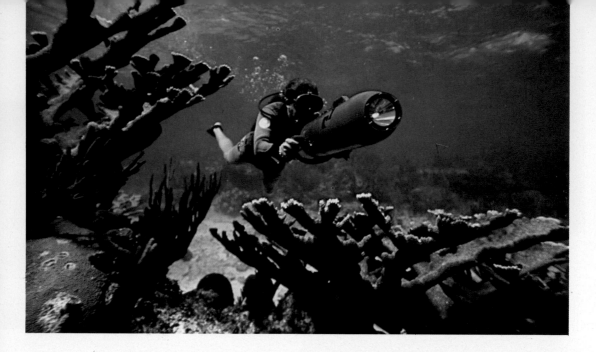

Diver propulsion vehicle off Freeport, Grand Bahama Island, Nikonos, extreme wide-angle lens in Schulke adapter. Ektachrome-X.

Flip Schulke

Gas-operated shark-dart weapon used at 8 ft. against "Dusky" shark, Nikonos with Fisheye 5.6 in Schulke adapter, Ektachrome-X.

One of Jacques Cousteau's divers off Madagascar collecting coral, Nikonos, old type 21/3.5 Nikkor in Schulke adapter, Ektachrome-X.

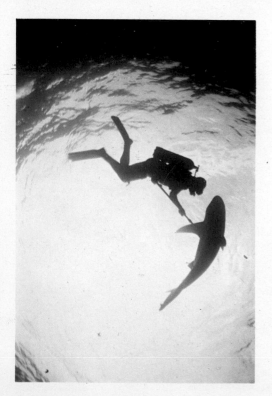

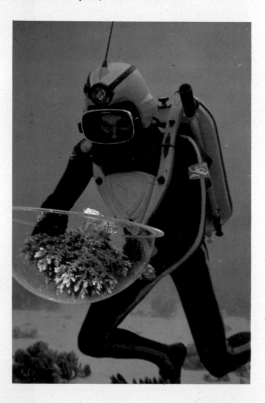

Tim Turnbull

All Turnbull close-ups made with motorized Nikon F, flash, Oceaneye 100E. Underwater Housing extended captions follow this color section.

Sharknose Goby on top coral covered with algae growth. 135/2.8 with Bellows III, flash f/8, 1/60 sec.

Cleaning Goby entering mouth of Red Hind, Nikon F motor drive, Micro Nikkor P 53/3.5, flash f/11, 1/60 sec.

Peterson shrimp resting around coral depression with anemone inside. 55/3.5 6 inches from subject, f/11.

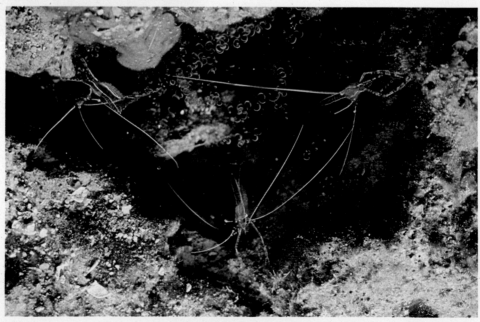

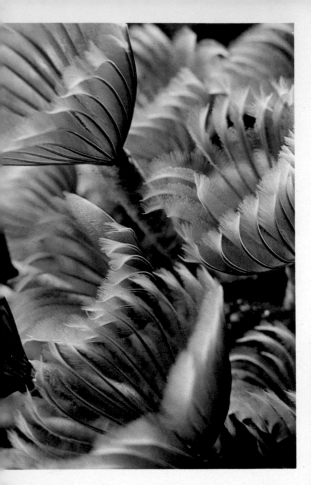

Serpulid feather-duster worm fully extended from protective tube. Micro Nikkor 55/3.5 plus M-ring, 1:1 ratio, f/11, Ektachrome-X.

Tim Turnbull

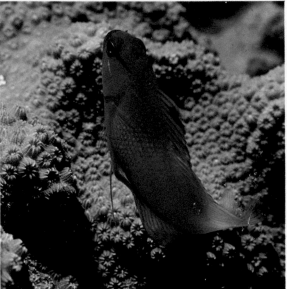

Turnbull waited one hour for fairy basslet to come into focusing range. Micro Nikkor P 55/3.5, M-ring, f/16.

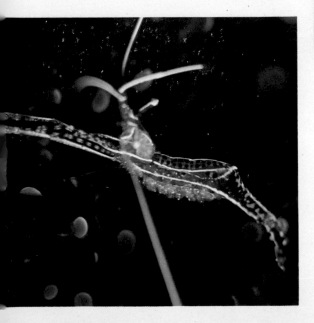

Peterson shrimp, 135/2.8 plus Bellows III at ratio almost 2:1.

All these Doubilet pictures made with Oceaneye Housing and Nikon F.

David Doubilet

An under-over shot. Half the lens (20/3.5) is under the water line; half above. Ektachrome-X.

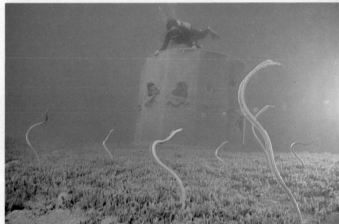

Eerie eels shot off the Sinai coast with 24/2.8 lens and specially made remote-control device. Ektachrome-X.

Details of lighting set-up with extended flat port on Oceaneye to simulate natural overhead illumination. 20/3.5 lens, High Speed Ektachrome.

Black tip shark being bound up. 20/3.5 wide angle lens permits full coverage at close quarters. High Speed Ektachrome.

Ground texture brought out by combination of sky lighting and portable light in diver's hand. 20/3.5 High Speed Ektachrome.

David Doubilet

For creative variation, Fisheye 8/2.8 used with Kodak Ektachrome Infrared to show diver's Unisuit.

All photos this page made with Nikon F, Micro Nikkor 55/3.5, electronic flash, and underwater housing designed and built by Bligh.

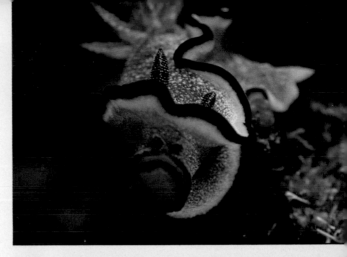

Dorid Nudibranch, close-up of rhinophores, lens reversed for 1.9X magnification, above, and 2.3 below, both f/16.

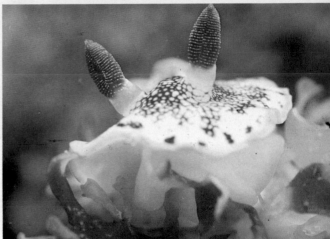

T. P. Bligh

Pencil Urchin. Lens in normal mode, f/16.

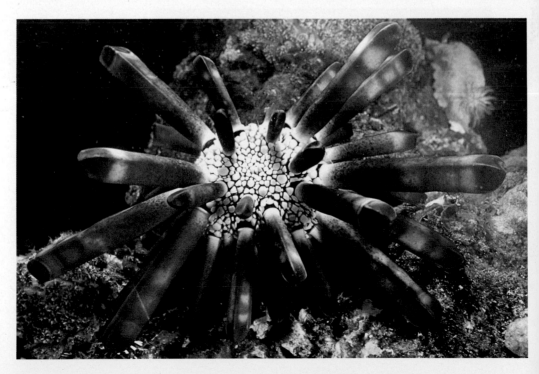

Dramatic silhouette of divers against surface. Note blue rendition with existing light. Giddings Nikomar IV housing, Nikon F, F36 motor drive, 20/3.5 lens, f/11, 1/125 sec., Ektachrome-X.

Another dramatic silhouette using diving chamber as composition prop. Same equipment, f/16, 1/125 sec.

Al Giddings

Hammerhead shark illuminated by surface light for characteristic blueness. Same equipment, f/8, 1/60 sec.

The "image multiplier" is a piece of window-screen material held approximately one inch (25mm) from front of Micro Nikkor 55/3.5 extended with two M-rings. Model behind moistened screen lit up by two 800-watt electronic flash units, f/16-22. Ektachrome-X

Al Satterwhite

Beyond the conventional wisdom lies the expanding theater of creative diversification or departure from the norm. The techniques include: (1) optical interference to alter the basic image, (2) manipulation of camera and lens controls to alter or disturb the image, (3) manipulation of materials in and out of the camera, and (4) creative use of reflections.

Scored glass "filters" create light spokes intersecting bright light points. Screen materials will do the same. 55mm lens.

Peter Millan

Ghost-like rendition 1909 Rolls Royce achieved with 12" (300mm) acetate sheet tubing before 35/2.8 lens, f/16, 1/60 sec. Kodachrome II.

Peter Keen

Richard Tucker

Five-faceted and three-faceted prisms combined in front of Micro Nikkor 55/3.5 for multiple-image effect.

Film through camera twice, once to record leaves out of focus, then to record figures in focus, 200/4 lens, Ektachrome-X.

Color sandwich, 35mm lens for lights, 200mm lens for skies, Ektachrome-X.

George Harvan

Double exposure, 105mm and 200mm lenses. Ektachrome-X.

Multiple-image effect achieved by zooming 200-600/9.5 lens on tripod during slow-speed exposure.

Peter Millan

New York skyscrapers: variations on a theme. Below, 80-200 zoom exposed for 30 sec. *f*/4.5 at 80mm, with vertical camera movement at end. Opposite page, top, multiple exposures, red, blue, green filters different times of day, Kodachrome II. Center, prism on 43-86 zoom at 86mm, misty morning, Ektachrome EF. Bottom, diffraction grating with 80-200 zoom at 105mm, Kodak Ektachrome Infrared.

Francisco Hidalgo

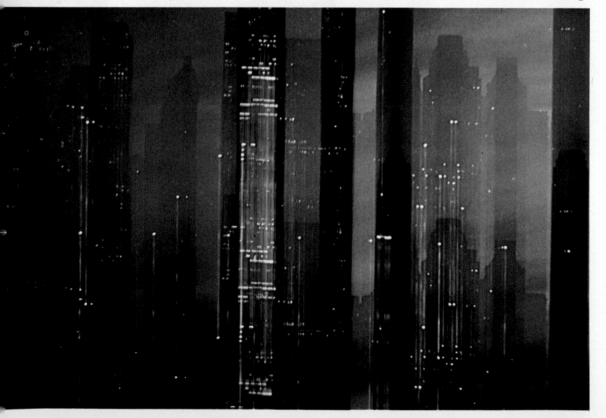

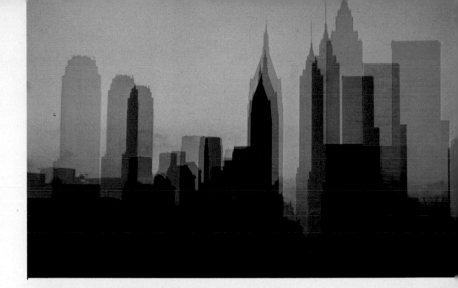

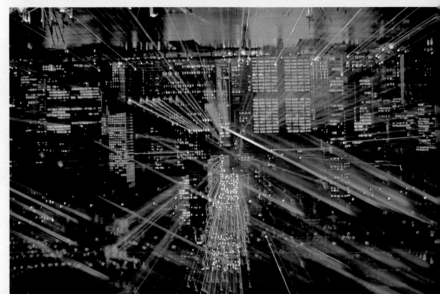

Francisco Hidalgo

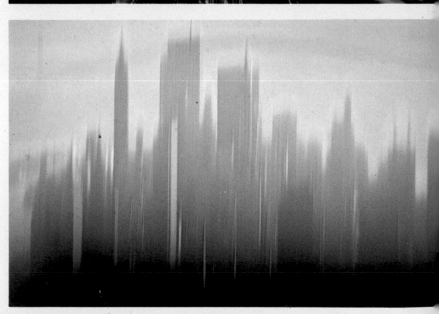

XVI-C-5

Double exposure, first of dress one stop under, second of head backlit by sun two stops under. Ektachrome-X.

Joe DiMaggio

Panning with 200/4, open, 1/15 sec. Central Park, N.Y. Longer lenses accentuate effect. Kodachrome II.

Graham Finlayson

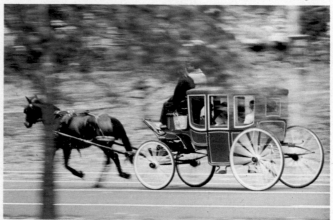

Triple exposure, tripod, Nikkormat through 61 green, 29 red+ .4 neutral density and 47 blue. Two stops extra exposure each. Kodachrome II.

Richard Tucker

Douglas T. Mesney

"Atomicolor" is Mesney's term for color variations using filters, manipulation of development chemistry, and slide duplication for contrast. Above, St. Petersburg, Florida, boat show, original 28/3.5 at f/16, 1/250 sec. Below, Ft. Lauderdale, Florida, 500/8 at 1/250 sec. Both motorized Nikon FTN.

Bob Nemser & Bill Jorden

Nemser-Jorden process based on reversals: positive to negative, negative to positive, green filters to give red, red filters to give green, magenta royal blue, etc. Variations include Kodalith for contrast; infrared for color alteration, double exposures, and successive duplication. All pictures Nikon FTN, Bellows III, Micro Nikkor 55/3.5, copy stand, light box. Above, combines two copies of original, High Speed Ektachrome Daylight developed as negative and infrared developed normally. Full details after this color section.

Kodalith negatives and positives combined to yield striking graphic effects. Lighter golds and less intense blues mix with more fluid reds, blues, and oranges. Subject is Louisa Moritz, comedienne-actress.

Bob Nemser & Bill Jorden

Above, two recopies of fainter positives montaged for dramatic effect.

Above, left, three Ektachrome negative copies combined to create sylph-like figure; book cover, winner of art directors' awards.

Bob Nemser & Bill Jorden

Suggestion of ballet. Each segment of combination recopied onto negative film and Kodalith until colors from each seep into other, then recopied through three generations.

3M Color Key effect achieved by combining third generation classical combination with first generation infrared copy of original.

Bob Nemser & Bill Jorden

Side pictures: Kodalith used for poster effect. Top, green negative copy (hence magenta) of original added to Kodalith black-and-white positive. Bottom, Kodalith b/w positive combined with infrared copy.

Pseudo-solarization. Original copied onto Agfa Positive M sheet film; after development, exposed to colored light, redeveloped, fixed, bleached, washed, dried, then recopied same procedure. Original 24/2.8 lens.

Richard Tucker

Flash provided dark background due to light fall-off. Color variations in background and foreground achieved by razor blade slicing of emulsion layers.

Francisco Hidalgo

Sandwichings. Note use in each photo of same window framing
superimposed on different backgrounds. Combinations of 55mm
and zoom 200-600mm lenses.

Peter Millan

Peter Millan **Francisco Hidalgo**

Reflections may be high-fidelity renditions, abstractions, or diffused patterns depending on water depth and "texture." Millan: slightly turbulent water breaks up image. Hidalgo: thin water coating reflects diffused pattern. Finlayson: reflection turned upside down to distort reality.

Graham Finlayson

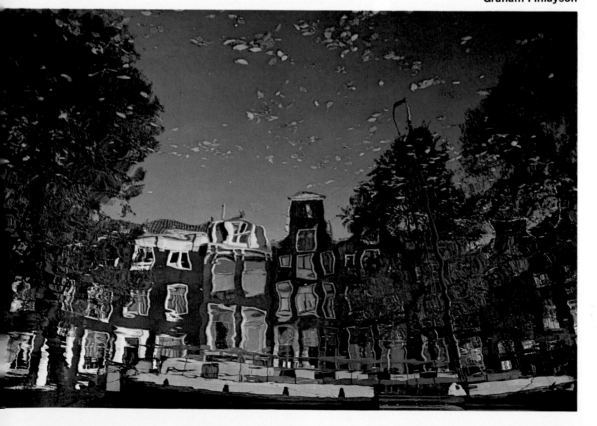

Ian Vaughan

Douglas Glass, British photojournalist, photographed on Malta: long lens fills frame tightly in portraiture. Daylight, compromise exposure for face and highlights. 135/2.8 lens, f/5.6, 1/30 sec. Kodachrome II.

Ian Vaughan

Head-and-shoulders portraits of Eartha Kitt and Alfred Hitchcock made with 85/1.8 and 135/2.8 lenses to fill film area, both f/2.8, 1/60 sec., Kodachrome II. Half-figure portrait of Bette Davis made with 50/1.4., existing light, High Speed Ektachrome B (tungsten) f/4, 1/60 sec.

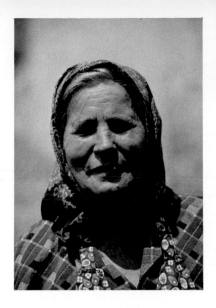

Small print shows effects of harsh overhead sun (Zagreb, Yugoslavia). Right, softer sun fills recessed eyes, mouth; relaxed subject can smile (Lake Bled, Yugoslavia). Both Zoom 80-200, Ektachrome-X.

Joseph D. Cooper

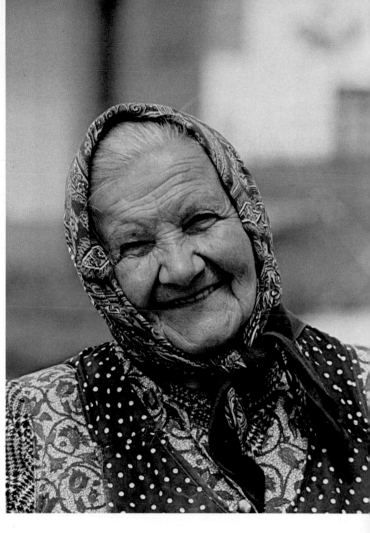

The informal portrait bounce flash combined with window daylight film, 35mm lens. Douglas Glass at home.

Ian Vaughan

Selectivity is achieved with 200f/4 which also offers good viewpoint. Backlighting pulls figure out of dark background. Kodachrome II.

Graham Finlayson

Selectivity and softened background achieved with 200f/4.Ektachrome-X pushed one stop because of poor light.

Fisherman at Stryn, Norway. Bright overcast has downward thrust. Note perspective effect of high lens viewpoint.

Mark Garanger

Children in courtyard. Chechaouan, Morocco. Movement of children caught by relatively slow shutter speed conveys mood.

Joseph D. Cooper

Zoom 80-200 permitted taking this selectively composed shot from low road embankment. Ektachrome-X.

Woman cooking (Sikwane, Botswana) was at distance, low angle with 200/4 lens which excluded nearby untidiness. Hand-held *f*/4, 1/15 sec., Ektachrome-X.

Struan Robertson

Al Satterwhite

Mood of the artist amplified with flare caused by shooting directly into carbon arc spotlight using 85/1.8 lens open wide. High Speed Ekta- chrome B (tungsten).

Long lenses magnify background compression. 500/8 focused sharply on subject sandwiched by out-of-focus floral matter. Highlight points are doughnut-shaped.

Ian Bradshaw

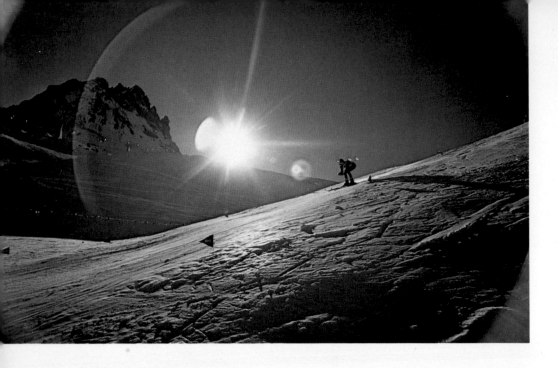

Noted ski photographer Peter Miller combining action with light. Skier coming down slope, Val d'Isere, France, caught just before he comes into sunburst, 24/2.8 lens. Left, skiers sandwiched with sunburst, diffraction screen, 105/2.5 lens. Right, ski acrobat Herman Gollner, sandwiched with blurry focus from lighting device, 200/4 lens.

Peter Miller

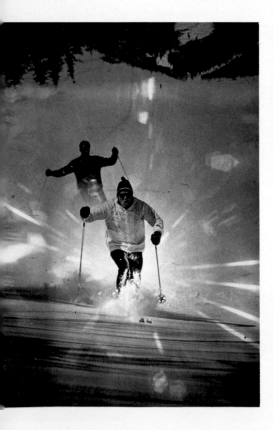

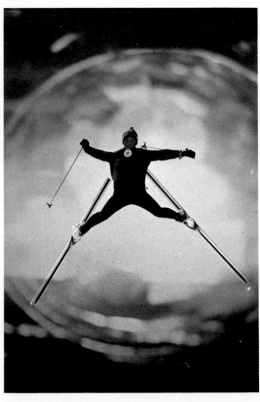

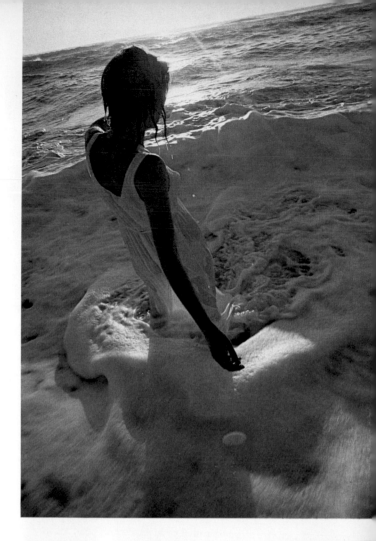

Frank Herholdt

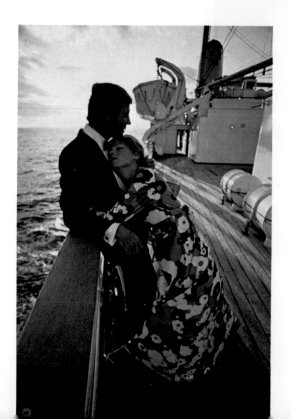

Both pictures taken with 20/3.5 lens and Kodachrome II to achieve desired perspective effects at close range—shrinking away of beach figure into swirling sea and sand—diminution of background aboard ship to concentrate on couple.

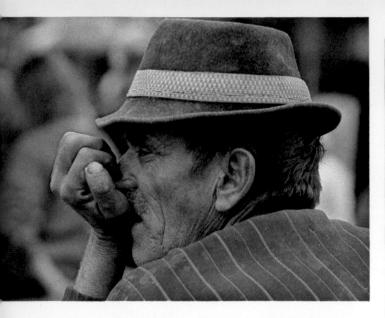

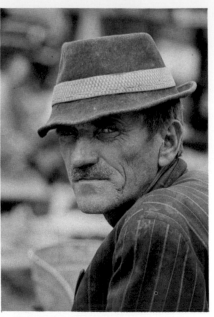

Zagreb, Yugoslavia. His characteristic pose was head in hand, but he preferred frontal. Sun behind thin clouds that yielded soft shadow-filling light. Zoom 80-200, Ektachrome-X. "During this trip through Yugoslavia I relied mainly on 24/2.8 and Zoom 80-200/4 to cover most perspective problems."

Joseph D. Cooper

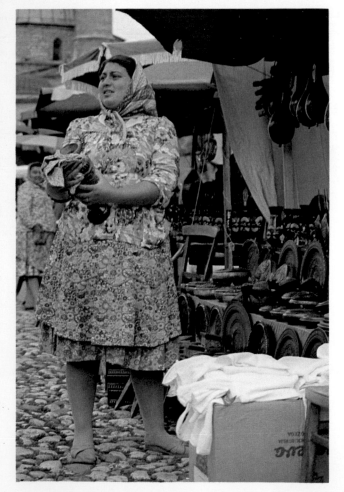

Sarajevo, Yugoslavia. She was torn between posing and trying to sell the photographer her wares. "My aim was to catch her in a characteristic pose, coordinated with brief movement of sun behind thin clouds." Zoom 80-200 at 80. Ektachrome-X.

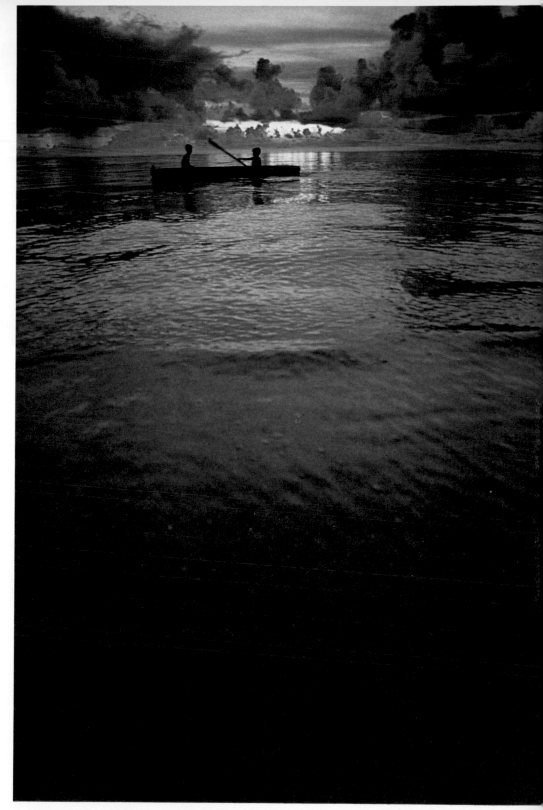

David Doubilet

Ceylon. Extended foreground effect achieved through use of 24/2.8 wide-angle lens, setting off bright interest center in background.

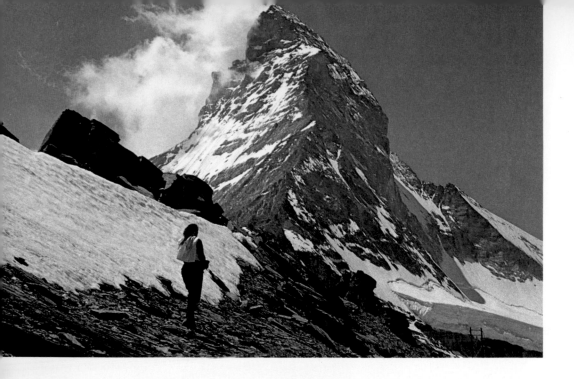

Matterhorn, Switzerland, summit pinnacle, summer. Sweep of mountain accentuated by lighting pattern. Nikkormat, 85/1.8, f/11, 1/125 sec., Kodachrome II.

Gerald Lacey

Skiddaw and Derwenter, Cumberland, English lake district, misty Autumn morning. 50/2, f/5.6, 1/125 sec., Kodachrome II.

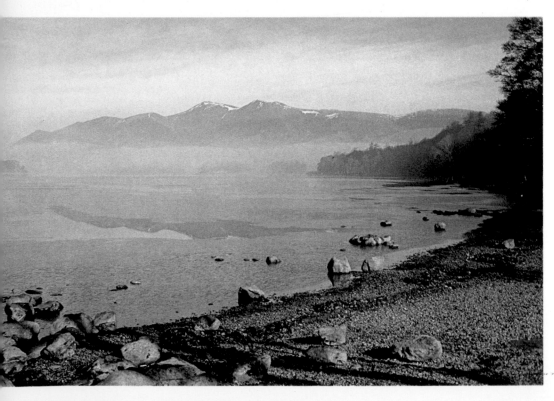

Joseph D. Cooper

Which lens for landscapes? Above, see it wide with 24/2.8. Or, see it long for selective composition with 80mm end of Zoom 80-200/4. Lake region near Julian Alps, Yugoslavia. Ektachrome II.

Joseph C. Abbott

The standard lens presents a pleasing perspective suitable for a wide range of subjects. Slope of Mt. Aetna, Sicily 50/1.4 at ƒ/4, 1/125.

Magnitude and majesty of nature accentuated through use of wide-angle lens while Kodak Ektachrome Infrared adds surrealistic color. Reflections in still lake add depth. 28mm lens at f/8.

Vernon Sigl

Afghan shepherd and flock set off against terrain, Afghanistan. Exposure was for dominant ground, thus taking care of shaded side of animals. 50mm lens, f/6.3, 1/125 sec. Kodachrome II.

Suzanne G. Hill

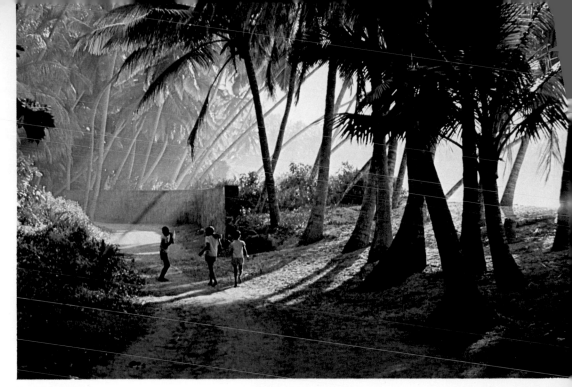

David Doubilet

Anawatowa, Ceylon. Selective composition through lens selection. Trees and shadows provided framing for children. 180/2.8, Ektachrome-X.

Scottish Winter. Back-lighting sets off trees from hillside. 200/4 at ƒ/5.6, 1/125 sec. Kodachrome II.

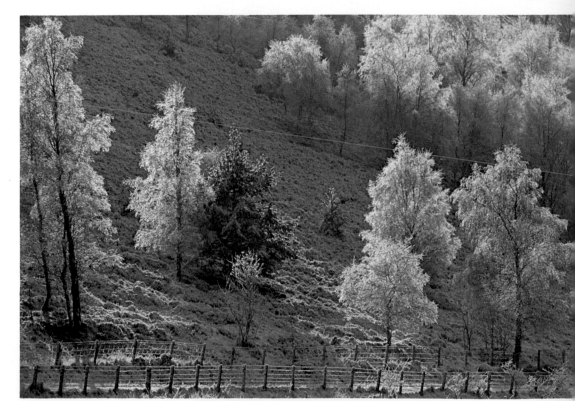

Suzanne G. Hill

Ice cave, Grand Island, Michigan. Exposure for large ice mass to render its texture. 105/2.5, tripod, f/11, 1/15. Kodachrome II.

Shaft of light. Exposure was for dark interior of woods at 6 a.m., thus burning-in shaft. 105/2.5 on tripod f/8, ½ sec., Kodachrome II.

Larry West

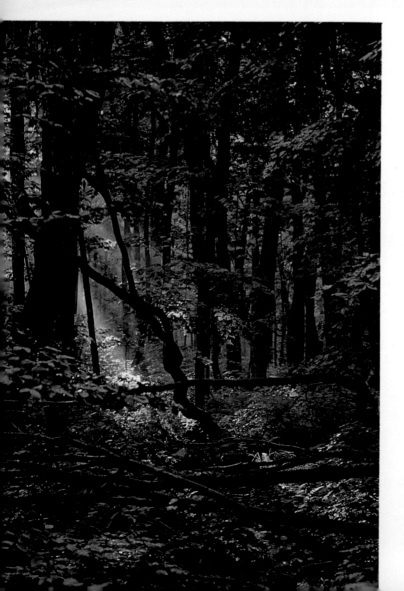

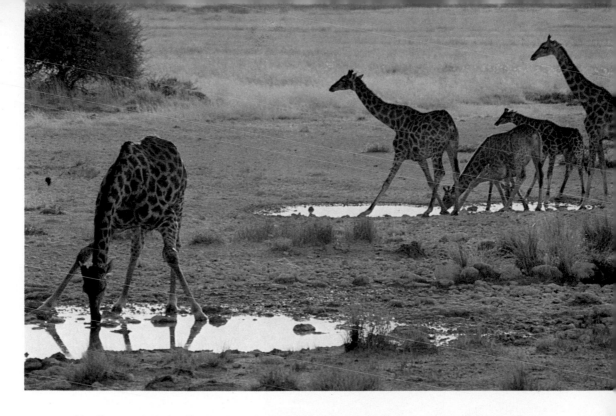

Giraffe at waterhole, Etosha Pan, South-West Africa (Namibia). Sun setting in muted pink light filtered through dust haze, contrasting with blue shadows on white sand. 300mm lens. Ektachrome.

Struan Robertson

Cattle entering Kraal, sunset, Botswana. Cattle important to tribesmen for export and as status symbol. 55/1.2 lens. Ektachrome-X.

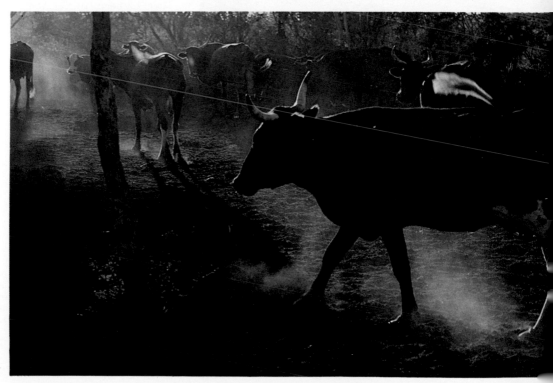

The long lens seems especially to have been made for plucking animals out of their backgrounds through selective focus. 600 f/5.6 wide open, 75 ft., Lion Country Safari, West Palm Beach.

Al Satterwhite

Vervet monkey, Kruger National Park, South Africa. 200/4 E2 ring to extend earlier model lens. Handheld on bean bag car window frame. Kodachrome II f/5.6, 1/125 sec.

M. Goetz

Barn owl (Tyto alba affinis), motorized Nikon F36 with 85/1.8 set up in tree; remote fired at critical moment; Nikon Speedlight. Kodachrome II.

T.P. Bligh

Dust and optical interference of bus window in Israel yielded mood picture.

Selective composition, Zoom 80-200, Nikon F2, f/4.5, 1/125 sec.

Joseph C. Abbott

Dramatically back-lit creature in San Diego Zoo pulled out of background with Zoom 80-200/4.5, wide open, 1/250 sec.

Sheep photographed for story on D. H. Lawrence in Sardinia. 35/2, ƒ/4, 1/30 sec. Kodachrome II.

Dan McCoy

Wild horses, Camargue, France. Taken from horseback so as not to disturb horses. For National Geographic magazine. 85/1.8, ƒ/8, 1/60 sec., UV filter. Kodachrome II.

Birds taken with long lenses in different settings and backgrounds for pictorial variety. Above, Greater Collared Gunbird about 8 a.m., 300/4.5 on tripod, remote release by air-trigger cable, f/8, 1/60 sec., Ektachrome-X. Below, left, Sacred Ibis, Austin Roberts Bird Sanctuary, Pretoria, 300/4.5, f/8, 1/125 sec., camera on bag, Kodachrome II. Right, Right Bishop Bird, 600/5.6 mounted on cradle support, heavy tripod, two E2 rings for close focus, f/5.6-8, Skylight filter.

M. Goetz

Bird against sky, 180/2.8, Kodachrome II.

David Doubilet

T. P. Bligh

Crested Barbet (Trachyphonus vaillantu) 85/1.8 with F36 motor drive and Nikon Speedlight set up in tree, fired remotely.

T. P. Bligh

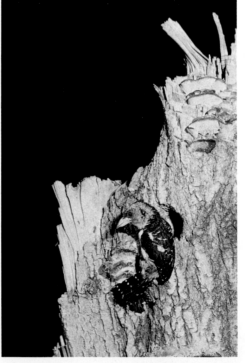

Late evening, f/11, 1/60 sec., background goes black due to diminution of light. "Ghosting" may result. Smaller f/stop, more powerful flash, would have darkened background.

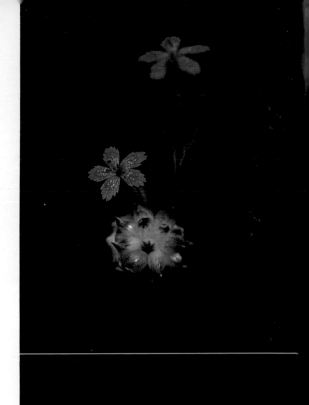

Close-in picture yields sharpness at selected plane, enhanced by dark background. Micro Nikkor 55/3.5.

Vernon Sigl

Windmill at Chatham, Massachusetts, out of focus, used as background for sharply focused red floral spots. 200/4 at f/8.

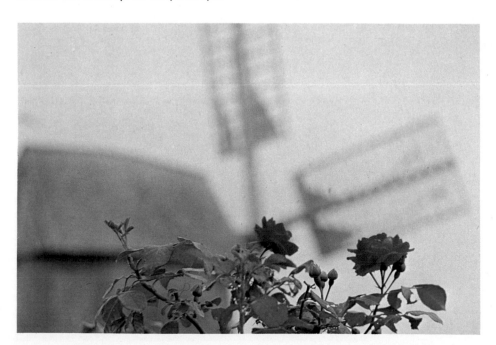

Color reproductions of various phases of lunar eclipse. Nikon FTN without lens mounted directly on 5″ f/4.8 astrographic reflector. (See explanation, Chapter 13)

Robert Provin

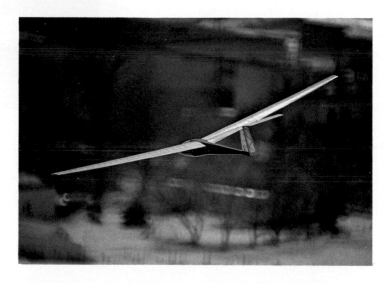

Robert Bickerton

Six-foot wing span of model plane (above) needed compression; achieved by backing away and using reflex Nikkor 500mm f/8 mirror lens. Interior of rocket engine (below made with Micro-Nikkor 55mm f/3.5 and electronic flash.

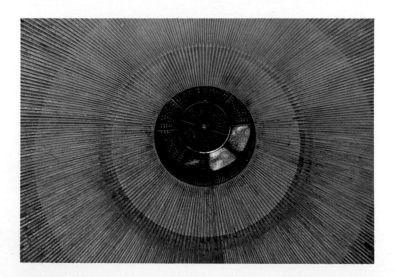